an intermediate guide to digital photography

ava

AVA Pu...
Switzer...

An AVA Book
Published by AVA Publishing SA
c/o Fidinter SA
Ch. de la Joliette 2
Case postale 96
1000 Lausanne 6
Switzerland
Tel: +41 786 005 109
Email: enquiries@avabooks.ch

Distributed by Thames and Hudson (ex-North America)
181a High Holborn
London WC1V 7QX
United Kingdom
Tel: +44 20 7845 5000
Fax: +44 20 7845 5055
Email: sales@thameshudson.co.uk
www.thamesandhudson.com

Distributed by Sterling Publishing Co., Inc.
in the USA
387 Park Avenue South
New York, NY 10016-8810
Tel: +1 212 532 7160
Fax: +1 212 213 2495
www.sterlingpub.com

in Canada
Sterling Publishing
c/o Canadian Manda Group
One Atlantic Avenue, Suite 105
Toronto, Ontario M6K 3E7

English Language Support Office
AVA Publishing (UK) Ltd.
Tel: +44 1903 204 455
Email: enquiries@avabooks.co.uk

ISBN 2-88479-025-X

10 9 8 7 6 5 4 3 2 1

Design: Bruce Aiken
Project management: Nicola Hodgson
Picture research: Sarah Jameson

Production and separations by
AVA Book Production Pte. Ltd., Singapore
Tel: +65 6334 8173
Fax: +65 6334 0752
Email: production@avabooks.com.sg

an intermediate guide to digital photography

john clements

contents

'Succulent Shades' by
Charlie Morey

introduction

What would the great artists or photographers of previous times have created if they had had access to the technology at our disposal today? We will never know, but they would almost certainly feel envious of our opportunities. To put it simply, there has never been a better time to be a photographer. In this digital age, we are fortunate to have the means to create images faster, of a more complex nature, and with more eye-catching results, than ever before. But, whether you are a keen amateur or an accomplished professional, there is always more to learn and experiment with, so how do you make progress once you have mastered the basics?

This book outlines ways to produce more accomplished work that you can be proud of, but without unnecessary complication when a straightforward approach performs the task best. It will help you to acquire the skills needed to create and use such fundamentals as the optimum workflow, output quality and imaging tools in order to produce consistently high standards of work.

Featuring images from photographers and digital artists from all over the world, it is also a useful and inspiring source of reference, standing not just as a 'snapshot' of today's styles and working methods, but also for the future, when the time-honoured basic techniques will still be required.

It is our hope, therefore, that you will enjoy this book, not just for the superb images that it contains, but the clear explanations of how they were created and why – and in turn that it will inspire and inform you.

There is something for everyone here: landscapes and still lifes; portraits and special effects; and, from the enthusiast to the professional, technical information that will be useful for advancing your own work.

Best wishes and good photography.

John Clements

'Transformation' by John Lund

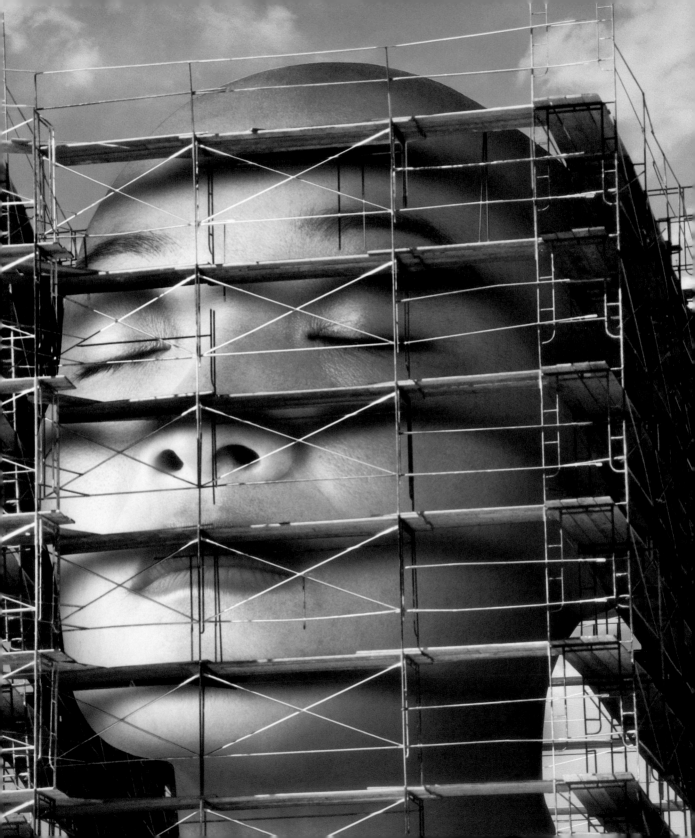

quotations

The photographer adds his or her own thoughts in their own words.

screengrabs

Often detailing the exact settings used for key stages of the photo-editing process, screengrabs make a quick and instructive visual check with which to follow the proceedings.

how to get the most from this book

In this book, the techniques of intermediate digital photography are presented in seven chapters. Starting with an overview of digital imaging at this level of skill, photographers outline how they tackle numerous subjects, both in camera and during post-production. Key components of the modern digital workflow are considered in detail during subsequent chapters. We also focus on specific styles of photography, including monochrome pictures and surreal and conceptual imagery. A glossary at the end of the book explains some commonly used terms in the digital arena.

Each spread is self-contained and explains either how specific images have been created in depth, or gives a brief overview of the important steps to accompany a detailed look at a particular technique or feature. Helpful quotes from the photographer or author put a personal slant on the information presented. Everything is explained from the photographers' 'hands on' point of view, not just from a theoretical approach. The design allows you to dip into the book at any stage to gain useful insight, without necessarily having to read the chapters and spreads in order.

The featured work comes from both professional photographers and talented enthusiasts, and there is something for everyone no matter what their approach or starting point.

introduction

An overview of the theme and techniques set out in the spread.

flow chart

A step-by-step outline of the main stages that the image has gone through is given in a flow chart. This allows a quick reference to the same or similar points of interest on different spreads. The flow chart also enables the reader to determine at a glance how simple or complex an image was to create.

'I work the subject, looking at it from all angles and shooting a lot in an attempt to find the ultimate image of that particular subject at that particular time.'

! Be careful not to overexpose. Detail in burnt-out highlights (pure white) can't be salvaged, although slight underexposure often can be recoverable via Photoshop layers with specific treatment to those areas.

using filters

Using filters in photo-editing software is a very useful way of enhancing an image, whether you want to make a startling and dramatic effect, or create something more subtle and atmospheric.

shoot

Charlie Morey is a professional photographer based in Los Angeles. This image, 'Blue Row Boat', was taken before Charlie started using digital SLRs with a digital compact. The exposure was 1/60 sec at f/2. image was created as file during a photoshoot Maine, to capture the foliage and other rustic scenes. It was just after

enhance

Charlie initially used Corel Photo-Paint as his retouching program. Adjustment was made for brightness, contrast and intensity, before a small amount of Unsharp Mask was applied to sharpen the shot. However, this appeared too much, so a Gaussian Blur overlay of the original image was placed over the top at around 40-50% transparency. This added a soft glow to the picture and was far more pleasing (2). At a stage, the image was using Photoshop, whe brightening and contra adjustments were ma Levels. The image was resized using Genuine software to approxima 14 inches, before sha blurring again with the effect.

> JPEG
> unsharp mask
> gaussian blur
> levels
> genuine fractals
> resized
> gaussian blur

2 gaussian blur

OK
Cancel
☑ Preview

100%

Radius: 0.5 pixels

3 gaussian blur

100%

Radius: 4.2 p

section title

Each spread is divided into the sections 'shoot', 'enhance' and 'enjoy'. 'Shoot' explains the background details up until the moment of capture. The choice of equipment and the context of the shoot are revealed. The 'enhance' section explains the process that the image has been through once in computer, outlining the stunning results that the digital photographer can create post-capture. The 'enjoy' section reveals how the image has been used for personal enjoyment or professional use.

images

The images in this book feature popular subjects such as landscapes, portraits, nudes and still lifes. We also showcase the ever-expanding genre of 'conceptual' images. All these types of subject matter have their place in modern image-making, and, from the traditional to the surreal, there are examples of images for people of all tastes to appreciate.

> ! From portraits to general scenes, Gaussian Blur (Filter > Blur > Gaussian Blur), is a wonderful tool. It enables an image to have varying degrees of blur introduced overall, or to just parts of the image if they are first selected. The effect can range from being virtually undetectable to complete distortion, leaving no sharp detail [3]. It can also be used to smooth out the impact of noise. The amount is set in pixels with a radius from 0.1 to 250, but be conservative: most subjects need only a small amount if they are to remain recognisable. Gaussian Blur works, like the less used blur filters, by averaging pixel tones adjacent in hard-edge or shaded areas, but is more controllable. In this case, a special mathematical equation is used (the Gaussian Distribution Equation). You can view the effect in a preview window in Photoshop, which can be magnified to display important parts of the image and moved around within via the Hand tool.

tips

Practical tips from the author and photographer allow the reader to apply issues raised in the images discussed to their own creative work.

...e coastal village of Castine that ...harlie noticed the boat and its ...vely handmade wooden ...ructure. The overhead angle ...om the wharf's edge gave an ...teresting perspective [1].

njoy

...Blue Row Boat' has proved a ...ersatile image. Gallery prints ...ave been sold to private ...ollectors, and it is included in the ...hotographer's 'Quiet Moments' ...ote-card line. It has also been ...onverted to a JPEG with ...ufficient compression to allow a ...easonable download time for web ...ewing.

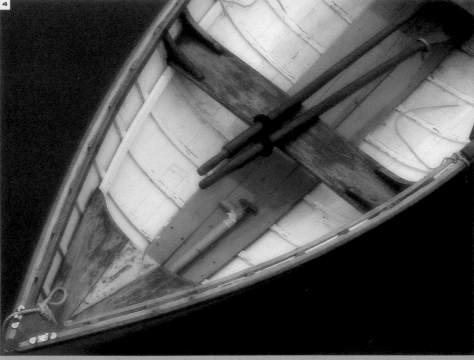

1/ The original image.
2/ Gaussian Blur is one of the most ...amatic and creative filters at our disposal.
3/ The final image.

captions

The image captions clarify and recap the processes shown in each image.

spread title

1 the digital mind-set

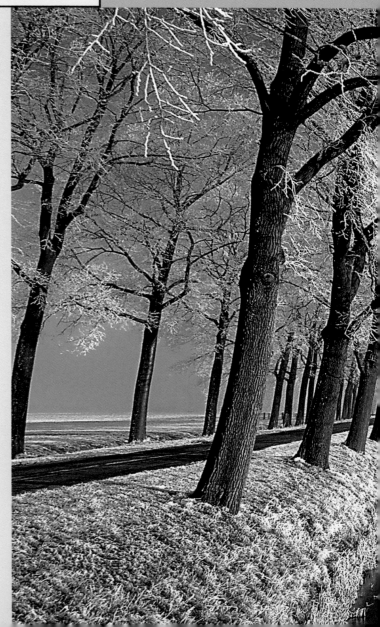

'Winter' by Jaap Hart

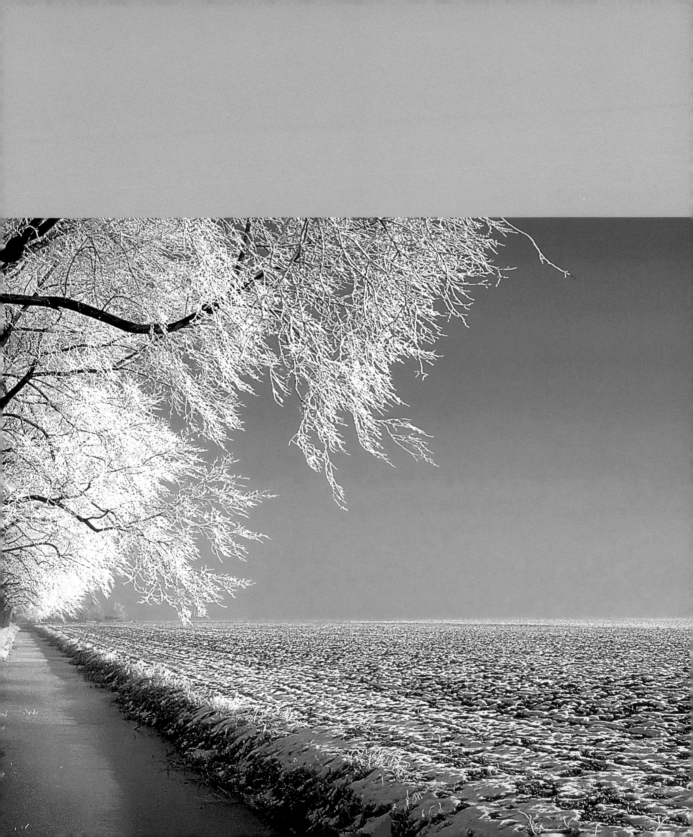

in this chapter...

Here we introduce some
of the most commonly
used techniques and
working practices in the
digital arena that will lead
you into creating dynamic
and striking images.

know your software

Here we focus on some of the
most useful features available in
digital-imaging software, including
file browsers and noise reduction.

pages 14–15

digitising film

Converting traditional film images
into digital versions ripe for
manipulation is a relatively
straightforward procedure, and
there are certain basic image
adjustments that can be made
with the scanner software.

pages 16–17

sensible touches

Making an effort to learn the nuances of your digital-imaging software will benefit your work. Here, we look at the advantages of batch processing and sharpening images.

pages 18–19

combining imagery: 1

The images in this section are an excellent example of the creative results to be had from digitising traditional film images and manipulating them in photo-editing software.

pages 20–21

combining imagery: 2

Here we look at how some photographers use conventional film capture as a means to an end in the digital arena: ultimately, the choice of capture is dictated by creative criteria.

pages 22–23

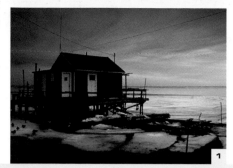

1

Curves
Color Balance
Unsharp Mask
Noise Reduction

Color Noise Reduction:

1

☑ Edge Noise Reduction

Size/Resolution
Bird's Eye
Information

know your software

As important as any camera or creative idea, software is the bedrock of digital image creation. Only a few types of programs are needed. A full-blown image-editing package such as Paint Shop Pro or Photoshop is a must, together with dedicated options from a camera manufacturer that enables RAW digital camera data to be processed. A file browser is also a good idea, whether it comes as part of a software program or is a standalone application. It is crucial that you feel comfortable with the options and interface, because without mastery of the program your results will not match your imagination. Here, we highlight some useful features that will help you maximise your workflow.

file browser

The file browser is an indispensable program that browses through the images on your computer system (or others if connected to them) and allows you access to them. File browsers may be incorporated into manipulation packages such as Photoshop. If you have lots of images, a file browser is essential to find what you want easily. Working on thumbnail images created from the larger files, sorting, deleting, rotating and renaming are possible with most file browsers. Thumbnails can be adjusted for size to make a detailed view of one image or overview of many images practical. File browsers also read meta-data, the textual information that accompanies a file. This gives useful information such as exposure capture details.

noise reduction

While it sometimes can be desirable to add noise to an image for artistic effect, as we will see later in the book, most of the time its removal benefits digitally captured shots. Setting control parameters allows detailed control to maximise image quality.

actions

It is possible to carry out some repetitive tasks automatically. If you wish, more complex aspects can also be automated. Actions in Photoshop enable us to work in a step-by-step way on an image, which acts as a template. Renaming and saving is a common need, but more advanced aspects such as applying USM (Unsharp Mask) can also be accommodated. Photoshop comes with a number of default options [4].

2 file browser

Shooting Data

Folders

Macinto
Hardisk
Hardisk
Desk
Fold

Disc bu

Circus/Clowns	Color Managm...	Dealers	Dunne London	General
Historic Biuldi...	JB Scanned I...	JS PLC	Natural World	People
Places	Product Tests	Test Images	Things	Transport

0 images 0 images selected

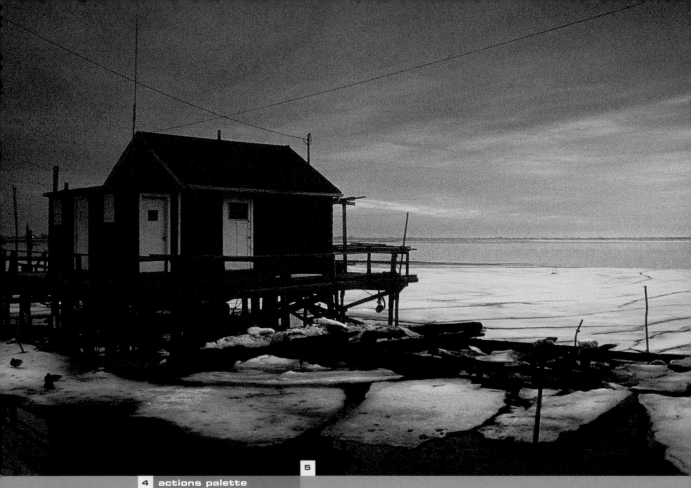

1/ The original image.

2/ File browser.

3/ Noise reduction.

4/ Actions palette.

5/ Creative use of software enables the creation of images like this one by George Mallis.

4 actions palette

| History | Actions | Tool Presets |

Default Actions.atn

- ▶ Vignette (selection)
- ▶ Frame Channel – 50 pixel
- ▶ Wood Frame – 50 pixel
- ▶ Cast Shadow (type)
- ▶ Water Reflection (type)
- ▽ Custom RGB to Grayscale
 - ▶ Make snapshot
 - ▶ Channel Mixer
 - ▶ Convert Mode
- ▶ Molten Lead
- ▶ Make Clip Path (selection)
- ▶ Sepia Toning (layer)
- ▶ Quadrant Colors
- ▶ Save As Photoshop PDF
- ▽ Gradient Map
 - ▶ Make snapshot
 - ▶ Convert Mode

5

filters

Where would we be without filters? Not only the filters used on camera, but, more importantly, those used within software. These enable a vast range of effects to be introduced into an image, from the subtle to the eye-catching. With many programs, filters can be added in the form of plug-ins. New types are being introduced all the time, so it pays to keep up with the latest developments.

masks

If your program has a Mask feature, it will prove its worth when it comes to maximising different parts of an image during manipulation. A mask protects an area you select so any changes that you make do not affect it. A colour (usually red) shows the area of the mask, which can be adjusted to suit. Masks can be saved for future use if needed.

! A 50MB file is a reasonable size if you need to use the image for a variety of uses, from photochemical reproduction to print enlargements.

! If you use a 35mm film scanner, choose one that allows batch scanning with numerous slides. Often an optional extra, a bulk film holder will simplify your workflow, especially if you are scanning a number of images shot under the same conditions.

1

digitising film

Images created by traditional film photography can be used in your digital imaging (1). However, scanning film and turning its analogue values into digital ones is an art in itself. Drum scanners represent the top end of the scanner market, but their cost is beyond most people's budget. Luckily, it is possible to use a desktop unit to obtain results of sufficient quality (2).

scan

When you are scanning, the best place to start, ironically, is with the finish. It is best to set the dpi (dots per inch), or resolution, with a target file size in megabytes (MB) in mind. If the file size is too large, you may spend time creating large amounts of data that then has to be thrown away later in the workflow. Large files will also swallow up storage space. After the initial pre-scan made at a low resolution, crop the image, losing any non-essential areas around the periphery, or even better, into just the parts of the image that you are certain you will need. A test slide (3), if your scanner allows it, can help you ascertain colour accuracy.

enhance

There are some key issues to tackle at the scanning stage within the dedicated scanner software. Some of these issues can also be resolved once the image is in computer with your image-editing program, but some cannot – or not as easily, anyway. The dynamic range can be controlled via a histogram (4) or by setting single black-and-white points (see pages 68–71). This will set the pixels chosen at either of the extreme tonal values. A histogram will also allow the midtones to be adjusted. Dedicated film scanners can tackle such tasks automatically, but it is often useful to make further adjustments from there. Once happy with the way the scan looks, many photographers use dust and scratch removal software if it is available. This can save time in retouching these areas later, but can also soften the image as a result. Extra amounts of Unsharp Mask (USM) (see pages 18–19) are often needed later in the workflow to counteract this.

> scanner warm-up
> pre-scan
> crop
> dynamic range
> RGB/CMYK file
> scan
> dust and scratches removal
> TIFF file

2

3 test slide

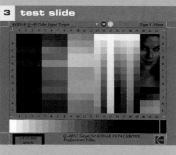

4 histogram

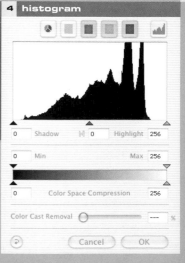

0	Shadow	0	Highlight	256
0	Min		Max	256
0	Color Space Compression			256

Color Cast Removal --- %

Cancel OK

5

1/ The original image for this digital montage by John Peristiany was a 35mm transparency film image.

2/ A desktop film scanner.

3/ To enhance colour accuracy, the best scanners come with an IT8 test slide or equivalent. These are manufactured to strict tolerances, allowing your scanner's results to be compared to ideal results that were created with the slide.

4/ A histogram display shows the range of tones captured and enables this to be adjusted for effect.

5/ The final image.

! **Old and faded film can often become usable by employing colour restoration software. This is often included within the scanner software portfolio. However, as with dust and scratch removal, applying it will significantly increase the scan time.**

enjoy

Once scanned, the image is best saved first as a TIFF file for stability (see pages 28–29). If you need a smaller file, convert the TIFF to a JPEG afterwards and save both versions. Regardless of the file format, a file saved in Red, Green, Blue (RGB) values will be smaller than a Cyan, Magenta, Yellow and Black (CMYK) file, as the latter has four as opposed to three colour channels.

! Advanced use of USM involves applying different amounts of USM to specific areas of the image. Digital capture with some cameras allows in-camera sharpening to be adjusted from zero (none applied) to hard (high sharpening). If you set a level in camera because you don't want to do much post-capture adjustment, such as when shooting **JPEG** files, you will need to test each level against the intended output to find the best one. For instance, if a wedding photographer has prints made onto silver halide paper, one level of sharpening for a given print size will often look better than another. This would usually be less than for a commercial photographer capturing product shots, for example.

sensible touches

Capturing an image, whether by digital or traditional means, increasingly takes up only a small percentage of the modern photographer's time. The software you use, how you use it, and other technical considerations, are just as important. Here are some key issues to aid successful image-making.

batches

We record an instant in an image, and can then spend hours working on that picture. Doing things in the simplest way makes our post-production time most effective. Batch processing (1) is a logical way to work when getting images into computer. On its simplest level, files can be renamed sequentially; images stored where you want; and file formats changed.

1/ Batch capture.

2/ As a guide, Photoshop's USM is usually most effective for high quality printed results with settings of 150/200% for the amount, 2–20 for threshold and 1–2 for the radius.

3/ This image, 'Cloud', was created by Allan Schaap by extracting the model shot and pasting it onto a background image of sky.

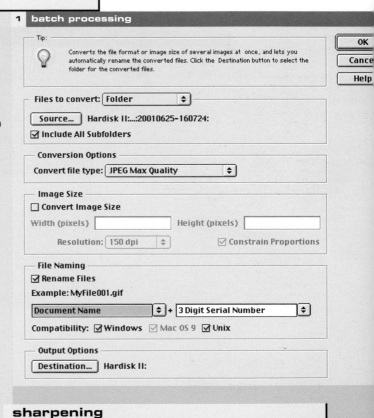

1 batch processing

Tip:
Converts the file format or image size of several images at once, and lets you automatically rename the converted files. Click the Destination button to select the folder for the converted files.

OK
Cance
Help

Files to convert: Folder

Source... Hardisk II:...:20010625-160724:

☑ Include All Subfolders

Conversion Options

Convert file type: JPEG Max Quality

Image Size

☐ Convert Image Size

Width (pixels) _____ Height (pixels) _____

Resolution: 150 dpi ☑ Constrain Proportions

File Naming

☑ Rename Files

Example: MyFile001.gif

Document Name + 3 Digit Serial Number

Compatibility: ☑ Windows ☑ Mac OS 9 ☑ Unix

Output Options

Destination... Hardisk II:

sharpening

! Many professional cameras set a low level of sharpening as standard, believing the photographer capable of adjusting it as needed for their output. Consumer compacts generally apply more as a default value. Test the options to find the best for the final use of an image.

Many images benefit from some degree of sharpening, and Unsharp Mask (filter > sharpen > Unsharp Mask) is the most popular method of effecting this. Sharpening adds localised contrast at the boundaries of certain pixel values, so do not overdo it or the image will look oversharpened. It should still look natural. Sharpening is nearly always best carried out at the end of the workflow, before passing files onto a third party or outputting yourself.

USM

Unsharp Mask (USM) [2] works by
increasing or decreasing the
contrast of pixels with those
nearest to them. We specify a
'threshold' to determine the value
at which the effect takes place. If
this is 0, all pixels will be
sharpened. As we increase the
threshold number, only pixels with
increasing amounts of contrast
between them will be affected.
We then set an 'amount' (in some
programs this is called intensity)
of contrast change to be made.
Finally, the radius or halo width
over which the effect takes place
can be set.

One reason for USM's widespread
use is the fact that it is
controllable: either a sharpening
or a blurring effect can be
introduced in the way that you
wish. Optimum use of Unsharp
Mask involves selecting specific
areas of the composition, and

3

2 unsharp mask

OK

Cancel

☑ Preview

100%

Amount: 50 %

Radius: 1.0 pixels

Threshold: 7 levels

sharpening these to the required
level, rather than making a global
adjustment. The lower the
amount applied, the larger the
output size can be, before the
effects show too much. If you
produce giant enlargements,

therefore, the usual viewing
distance means that it may be
best to do little or even no
sharpening. Conversely, medium-
sized prints, at 10 x 8 inch or A4,
for example, benefit from a
moderate amount of sharpening.

! Why not batch
process JPEGs into a
folder marked as
'copies' ready to work
on, then put the
originals into another
folder ready to burn
onto a CD as 'masters'.

combining imagery: 1

John Deaville describes himself as a photo-illustrator. As such, photography is only one part of his approach to image-making. The images here show that it is the final image, not how you get there, that counts. It also shows that combining different types of images, including film-captured ones, into digital form has a major place in the creative image-maker's life.

shoot

For his original images, John uses film capture – either medium format or 35mm film. The latter was used to capture the main image shown here, 'Rob', which was taken with an 85mm lens. Black-and-white film was used in this case, although John's advice is to shoot in colour to capture maximum detail, which can always be removed afterwards if necessary.

3 blending options

3/ Blending options allow plenty of creative control.

enhance

The image 'Rob' was created following a similar process to the alternative 'Ed' series also shown here. After printing, the original (1) was scanned using a flatbed rather than a film scanner. A second image consisting of a painted acrylic sheet (2) was also scanned and turned into a high-contrast monochrome image. Then, taking both images into Photoshop, the painted image was placed using Layers over the first shot. Adjustments were made using the Multiply and Screen blending options (3) (Layer > Layer Style > Blending Options), while another step used the second image as a texture map to distort the original. The image was then converted into an RGB image from CMYK (the painted image) and Greyscale (the original), then flattened. The final touch used a red layer with a Soft Light blend, plus a yellow layer with Multiply blending selected, to achieve a pleasing monochrome effect similar to filtration on camera (4/5).

1/ Original 'Ed' shot.

2/ Painted acrylic sheet.

3/ Blending options allow plenty of creative control.

4/ 'Ed', the final shot.

5/ This image, 'Rob', went through a similar production process as 'Ed', using layer blending and adjustment layers to burn in specific areas to emphasise the paint texture.

> 35mm film capture
> flatbed scan
> greyscale
> acrylic sheet
> flatbed scan
> CMYK
> Photoshop
> layer
> adjustment layer
> blending
> texture map
> RGB
> blending
> flatten

! If you want to change backgrounds digitally, shoot the subject against a white backdrop. This makes it easier to blend another image in or to remove the subject later. If you want to montage images together, make sure they have similar lighting.

4 5

enjoy

These and similar images can be seen on the artist's website. A painter commissioned the shot entitled 'Ed'.

> 'Digital photography is like a chain; the beginning must be perfect through until the end.'

❗ Amplifying a sensor's electronic signal increases its ISO equivalence. Such a flexible speed change is a major advantage for digital capture.

GretagMacbeth™ ColorChecker Color Rendition Chart

1 2

combining imagery: 2

The choice of whether to use digital or film capture is much like the debate between shooting colour or monochrome. Ultimately, your type of subject and your personal preference will determine which route is best for you. A lot of photographers regard choice of capture simply as a means to an end.

shoot

Netherlands-based Theo Berends uses both film and digital capture. For this shot, 'Cat Woman', he used a 6 x 6cm medium-format film camera, fitted with its standard 80mm f/2.8 lens and loaded with black and white negative film. Theo was inspired by the ambience captured by the photographers of the 1920s and wanted to create something similar. This shot was taken with ambient light exposure only, but very nearly at open aperture.

❗ *Why digitise film?* Since digital cameras have become suitable for more serious photography, it has been all too easy to overlook the proven high quality of film. It does take longer to shoot, process and scan material, but the finest quality for many types of subject still comes from film capture. Once a film-captured image has been digitised, the file size is usually bigger and contains more detail than a digital-captured image. Medium- and large-format photography, for example, has a tonal range not yet equalled by digital capture at a comparative price. Equally, with this aspect, few small-format digital cameras can achieve results comparable to 35mm film. If that is what you need, then you should be looking at a full-frame digital model. Other technical benefits of silver halide capture include better long exposure results; extremely fine grain; and mid to fast ISO ratings, which suffer far less from grain than digital capture does from electronic noise.

enhance

Photoshop was used to give the image the final coloration shown here, but only after the photographer had a high-quality scan made on a drum scanner from the negative. Many consider drum scanners to be the ultimate in scanning quality. The expense of the equipment, however, makes this a job for your lab or bureau. In total, around one hour was spent working on this image.

❗ Any digital camera sensor has a nominal sensitivity to light. We use this as an equivalent ISO rating, the lowest speed we can set. Unlike film, which utilises an increased size of silver salts to capture more light in faster emulsions, and hence has a higher speed rating, a sensor is 'uprated' instead. In turn, the characteristics of the results differ too. With digital capture, amplifying the captured electrical signal to 'uprate' provides a higher ISO. This also magnifies electronic noise inherent in the image, making it more prominent.

However, this adaptability is still a major benefit for digital capture, as the ISO can be changed to suit the subject and scene, from shot to shot. For instance, if you use on-camera flash, and need to increase the range that it covers, you can increase the ISO as an alternative to opening up the aperture on the lens, as you would need to do with a film camera. This approach also means that you get more control over depth of field. Finally, features such as colour aliasing may also show as an image defect.

> 6 x 6cm film capture
> drum scan
> Photoshop
> print

! **Be sure you are working with a calibrated monitor.**

1/ A scanned 35mm film image can yield a wider tonal range compared with many small-format digital cameras. It can also reproduce better where there are lots of dark areas.

2/ A colour chart like this is manufactured to strict tolerances. Its colour patches represent, amongst others, natural tones. It can be used for evaluating various things.

For instance, the mid-grey patch can be analysed as a good indicator of how much noise may affect an image at a specific ISO. Testing your camera under the lighting you normally encounter, at various ISO speeds, will give a guide to the most useful settings.

3/ The final image.

enjoy

This image has appeared in several exhibitions.

3

2 digital capture

'Frog' by George Dangerfield

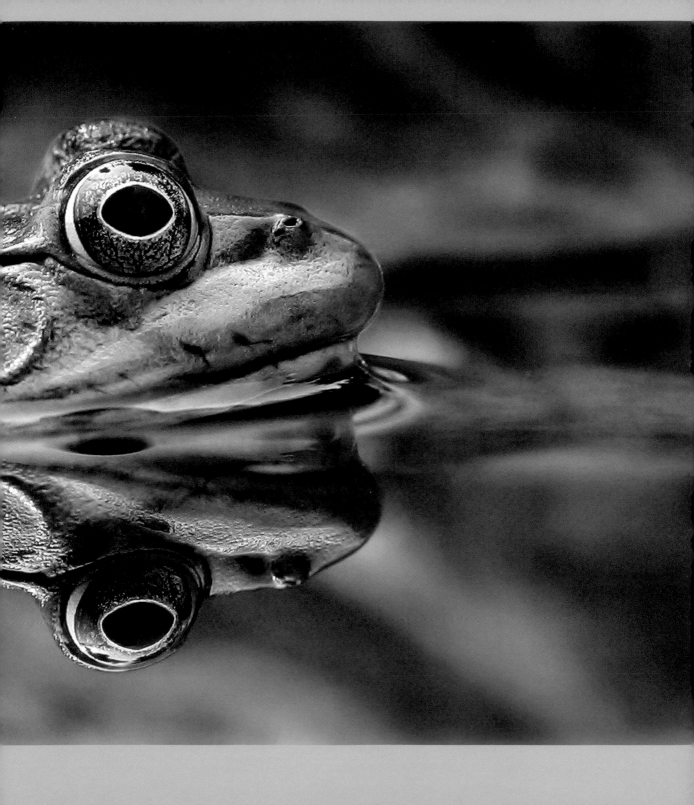

in this chapter...

Digital capture vastly increases the creative potential of your images, but it also requires you to consider technical factors, such as choice of file formats, and establishing an efficient working practice to store and retrieve your pictures.

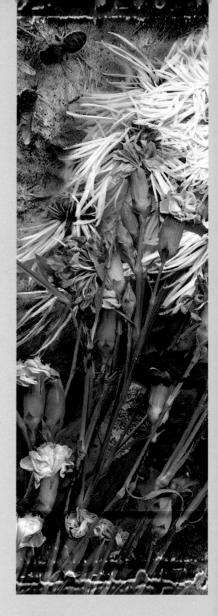

out-of-camera files

You can save your images in a number of file formats, the most common being JPEG and TIFF. Each has its merits, and your choice of which to use will depend on how you intend to use the final picture.

pages 28–29

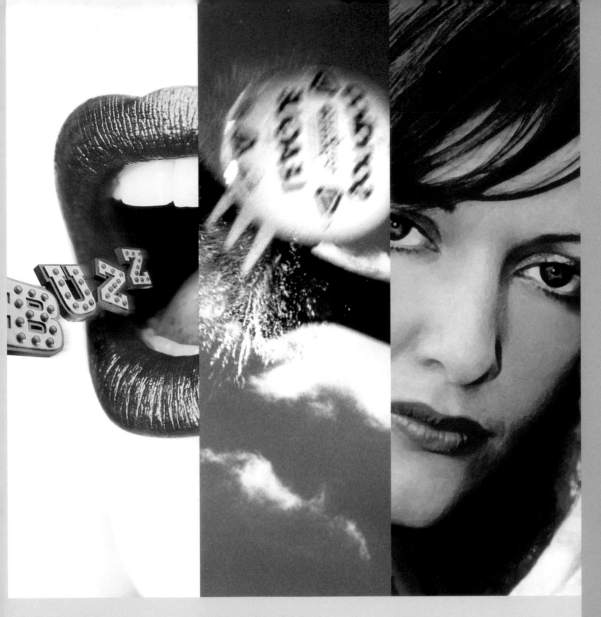

commercial quality

Digital capture is the preferred choice for many professional photographers, especially for the creation of eye-catching commercial imagery that would be almost impossible to produce by conventional means.

pages 30–33

good working practice

To get the most from your digital equipment, you should establish good working methods, including storing and labelling your files in a way that makes them easy to retrieve, and filling in file information to assert your copyright over your images.

pages 34–37

RAW data

Here we look at the benefits of using RAW data, which is often described as a digital negative.

pages 38–39

shoot

Image data, from the moment it is captured by a digital camera, exists as RAW data. This is the basic, unprocessed data that the camera's sensor and software produce. The process that works or develops the digital image is unseen, and enables out-of-camera files to be had relatively quickly. Georgia Denby captured the image shown here, 'Funeral Flowers', using a 3Mp digital SLR. Georgia was attending a funeral and noticed these flowers, which had been left over from another funeral. The idea was to recreate a similar image at a later stage. The shot was processed from its RAW data and converted in camera to a JPEG file.

out-of-camera files

Digital images can exist in a number of formats, just as a film image can be a positive or negative in analogue form. However, with digital images, there is a larger number of options and far greater flexibility. You should choose the format that best serves your photography, as each has its pros and cons. The best option depends on your specific needs, such as speed or maximum long-term flexibility. For instance, a scanned image for web use has a very different requirement to one intended for magazine or book reproduction. If you want files ready to use out of camera, and to provide maximum compatibility with other people's software, then a **JPEG (Joint Photographic Experts Group)** or **TIFF (Tagged Image File Format)** file from digital capture or scanned film original are the best options.

enhance

The image was manipulated in various ways in Photoshop. Many of these stages involved the use of layers. For reproduction in this book, the image was eventually saved as a CMYK TIFF file of around 30MB. Many cameras enable a TIFF file to be created from the RAW data while in camera, and this is the best quality option at this stage. As soon as an image is uploaded, or placed onto a storage card, many image-manipulation programs can read the data, which has been processed for colour or monochrome values, plus image sharpness from its raw form.

A TIFF file is large in MB terms, as the data is not usually compressed. The uncompressed file is desirable for reproduction in magazine and book form, or for other commercial printing requirements such as calendars, because they contain so much information. This information is necessary to reproduce a good-quality, sharp image with a smooth and continuous tone. The downside is the large amount of storage space each image takes up, and the time it takes to write data and move it around. If you need to capture images quickly and back to back, or wish to use the image for low-resolution uses such as on the web, a TIFF file is not the best choice. However, if you need high-quality out-of-camera files, a TIFF file should be your first choice. TIFF files contain lots of information and like JPEG files, most are comprised of 8-bit data. While many software packages will only work with 8-bit data, the 16-bit image also has an important role to play.

The JPEG format is another commonly used format. A JPEG is a compressed file, which means that it takes up less storage space. Its faster writing speed also makes it suitable for more rapid capture than TIFF files, and over a greater number of shots back to back. This is because its small size does not fill up the camera's buffer memory as quickly. But the fact that JPEGs are compressed means that a lot of colour data is thrown away that cannot be replaced in the file later, although enough is left for us to visualise a normal image. Each time the file is saved again, the compression process takes place on the remaining data. This is a cumulative process, meaning that the quality of the image degrades each time you save it. If you only shoot JPEG files, it is advisable to save a copy of the original and work only on copies of it.

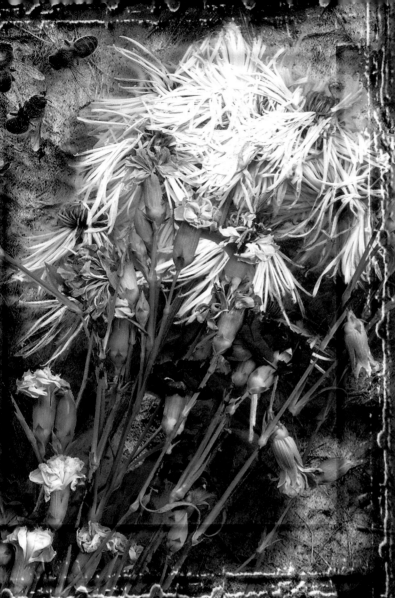

1/ The original TIFF file at 30MB. The same file saved as a maximum-size JPEG would be 14MB.

2/ A detail from the TIFF file.

3/ The same detail from a low-resolution JPEG version.

4/ The same detail from the 'saved for web' reduced size version.

5/ When the Save for Web option is used, a preview is displayed which, when zoomed onto, will show you the visual deterioration incurred with different JPEG settings. Web images do not benefit from being saved larger than they will be viewed, so this picture has also been scaled down to 700 pixels high.

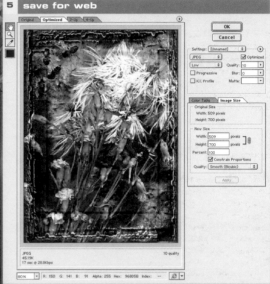

5 save for web

> **!** Once you are sure that the JPEG copy you have worked on is finalised, save that file as a TIFF file for stability.

enjoy

TIFF files give stability as they are uncompressed, and are not affected by repeated saving of the file. Most people will work with RGB TIFF files, but some people who are sending work for reproduction will provide CMYK files instead. If in doubt, supply the former, as many print reproduction companies prefer to do their own RGB to CMYK conversion.

For high-quality printing onto silver halide paper, TIFF files can be used, but some high-street systems find it easier to recognise a JPEG file. If you make ink jet prints, then a good-sized JPEG file is best. TIFF files can slow down the printer driver software. In addition, it is advisable to use a low-resolution JPEG for the web as these load faster for the viewer and take less time to upload to your website.

1

commercial quality

Commercial and advertising photographers are at the cutting edge of digital photography. Los Angeles-based Caesar Lima uses both film and digital capture, but most of his work is digital, which allows him immediate feedback.

shoot

'Buzz Lips' was created for an art director who wanted an image that had high impact, yet was both simple and powerful. The model and the letters were shot separately and then composited in Photoshop. A 6 x 8cm film camera was fitted with a digital back. A 100mm lens was used for the model shots (1–5). These were lit with softboxes fitted to the main lights in the studio. The shots of the letters were captured using a 35mm-style digital SLR fitted with a 180mm lens (6/7). These images were saved as JPEG files, while the model shots were saved as larger TIFF files.

2
3
4

enhance

With the model shot, Caesar had to manipulate the skin tones to knock back the colour so the lips would stand out. With the shot of the letters, the perspective was altered so it would suit the final image, and the feeling of motion was added with a Blur filter. Working with layers was important as different effects were tried out. The layers were flattened (Layer > Flatten Image) and the result was then saved as a PSD file (8). This stage involved changing the colour of the letters (9), and then combining the images of the lips and the letters (10). In total, two days were spent on this image.

> multi-format digital capture
> small-format digital capture
> TIFF files
> JPEG files
> Photoshop
> blur filter
> layers
> PSD file
> Photoshop

5

❗ **Be organised, have a fast computer and a great printer.**

1/ 2/ 3/ 4/ 5/ The model tried various poses to obtain the best shot of her lips.

6/ 7/ The letters were captured with a 35mm-style SLR camera and saved as JPEGs.

8/ The image was saved as a PSD file.

9/ The colour of the letters was changed in Photoshop.

10/ The two images were combined in Photoshop.

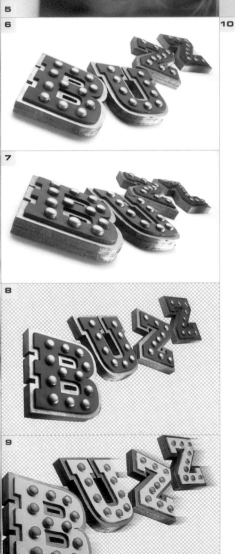

6

7

8

9

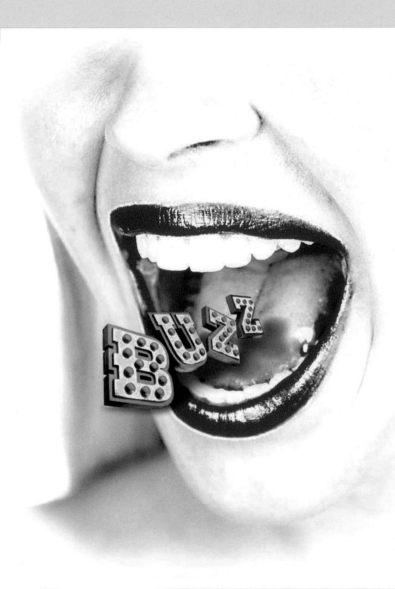

10

75090

11 Caesar produced a number of alternatives for the client to choose from (11–15).

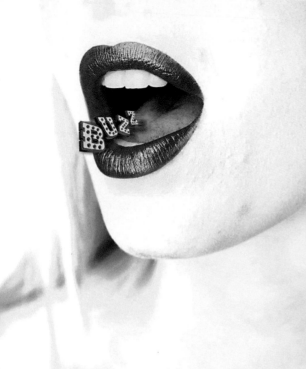

12

13 14

enjoy

Caesar makes prints for reference only as most of his work is printed in CMYK (lithography). This image was used for a Network News magazine cover.

11/ 12/ 13/ 14/ A series of alternative shots was created.

15/ The final shot used on the magazine cover.

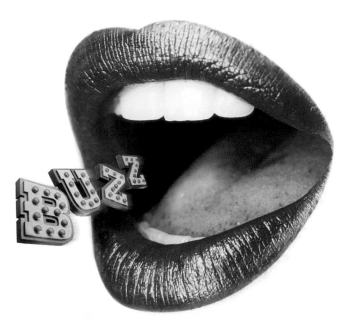

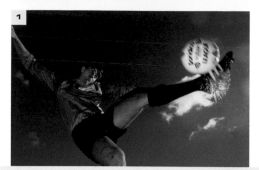

1

A file browser is fundamental to storing and editing your work, either as a standalone or part of a large image-manipulation package. Get rid of any shots that are obviously of no use, but store and caption those you keep as soon as you can, while things are clear in your mind.

good working practice

If you own a digital camera, you will know that it is quick to see results, and cheap to run after the initial equipment outlay. But how do you ensure that you are getting the best from your digital camera? Different people have different ways of working, and no one method is ideal for all subjects or circumstances, but using the correct feature at the right moment will save time in the long term. And effective post-production starts with having a good image to work with.

> TIFF file
> Photoshop
> flip
> levels
> white point
> variations
> magazine repro

shoot

I took this image of a soccer player with the help of two assistants. One threw the ball after wetting it with water so that we could capture the 'splash' on impact. The other held a gold reflector low down to bounce light back into the subject's face. I wanted to use the sky as a natural backdrop, so I set my exposure manually to reproduce this correctly with its deep blue tone. These settings would have left the subject slightly underexposed, so a hotshoe flash was used to provide fill-in illumination. Using a histogram is invaluable when you have the time to judge the situation after a test shot, and you should either set your white balance to auto, or measure it manually (see page 36). The next issue to tackle was what angle to shoot from. In the end, the camera was held above my head and angled slightly, while I lay on the floor facing the sky. Then it was just a matter of timing. Digital capture, and assessment on the camera's playback facility, are fundamental to a good workflow.

2 **file browser**

Hardisk II:Folders:Images:Transport:Boats/S...

DSC_0023.JPG
Rank: -

DSC_0164 copy.jpg
Rank: -

DSC_0176 copy.jpg
Rank: -

DSC_0325 copy.jpg
Rank: -

DSC_0326 copy.jpg
Rank: -

DSC_0329 copy.jpg
Rank: -

DSC_0332 copy.jpg
Rank: -

DSC_0335 copy.jpg
Rank: -

DSC_0344 copy.jpg
Rank: -

DSC_0424 copy.jpg

DSC_0425 copy.jpg

DSC_0426 copy.jpg

Filename | Large with Rank | 43 Item(s)

❗ If you are in a hurry on a shoot, but have enough post-production time, capture **RAW** files. These give maximum options to correct imperfect settings.

❗ It can be worth completing other sections of File Info, such as copyright details at the very least.

3 exif info

Section: EXIF

Exposure Time	:1/125 sec
F-Stop	:13.0
Exposure Program	:Manual
ExifVersion	:0220
Date Time Original	:2002:12:11 17:34:35
Date Time Digitized	:2002:12:11 17:34:35
Components Configuration	:Unknown
Compressed Bits Per Pixel	:4.0
Exposure Bias Value	:0.0
Max Aperture Value	:4.3
Metering Mode	:Pattern
Light Source	:Unknown
Flash	:Did not fire.
Focal Length	:66.0 mm
User Comment	:
FlashPix Version	:0100
EXIF Color Space	:sRGB
Pixel X Dimension	:3008
Pixel Y Dimension	:2000
Related Sound File	:

OK
Cancel
Load...
Save...
Append...

❗ When you have different variations of a shot, where you have used a different camera angle or changed the subject's clothing, for example, it is a good idea to place these images in a separate folder on your storage card for easier retrieval. Likewise, using a sequential numbering system will give a unique title to each shot even if you use more than one folder or storage card.

enhance

After taking the image into Photoshop, it was flipped to face the other way via Image > Rotate Canvas > Flip Canvas Horizontally. Then, using Levels and the Eye Dropper tool, a white point measurement from the clouds was used to clean up the exposure: Image > Adjustments > Levels. This was still not quite right, so Variations (Image > Adjustments > Variations) were used to select a slightly lighter version.

1/ The original image.

2/ File browser.

3/ EXIF (Exchange Information Format) information can help guide you if things go wrong or if you want to judge differences between shots and the settings used. Cameras write this information with a file as part of its meta-data, and various programs can read it. In Photoshop, this data is opened through File > File Info, and then selecting EXIF from the drop-down menu.

4/ Many photographers overlook the ways in which they can indicate their rights. Filling in file information is one way.

4 file info

File Info

Section: General

Title:	
Author:	
Author's Position:	
Caption:	Soccer player in flight
Caption Writer:	
Job Name:	Soccer shoot 2003
Copyright Status:	Copyrighted Work
Copyright Notice:	©John Clements
Owner URL:	

Go To URL

OK
Cancel
Load...
Save...
Append...

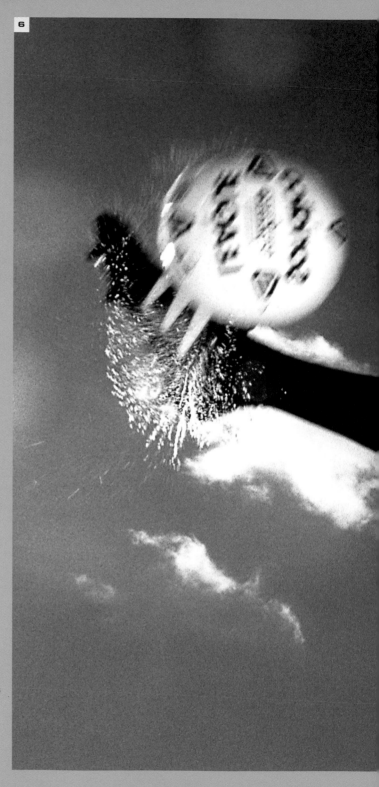

5/ A Neutral grey card is useful in or out of the studio for setting a white balance measurement.

6/ The final image.

! If your camera has a white balance bracketing feature, why not use it? Sometimes an image with a touch of extra warmth or coolness can add character to a shot.

! *White balance* Getting the best white balance setting is important if the overall colour of the image is going to look correct. It can be adjusted post-capture, but this is not always a practical option, especially if you need out-of-camera files such as **JPEGs** or **TIFFs** for speed. Our brain adjusts automatically so we perceive most colours as being correct under different light sources, but cameras need some help to register this. Film cameras require time-consuming filtration to correct white balance, but digital capture has the advantage here as white balance can be measured. This is done by filling the frame with a white object or neutral grey card, then using the on-board measurement feature control.

enjoy

This image has been published in numerous magazines, and makes an interesting subject matter for discussion in my seminars.

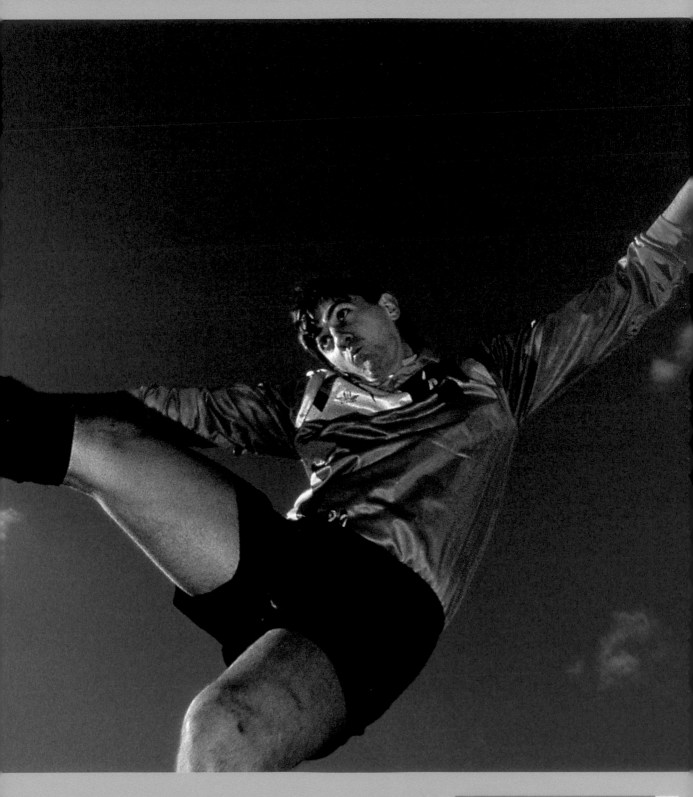

! A **RAW** data file is the ultimate out-of-camera option. It is rightly referred to as the digital negative. It is also smaller than a **TIFF** file, but, like a **TIFF**, has lossless characteristics. Lossless images do not lose data by repeated saving of the file.

! One significant aspect of **RAW** files is that they allow you, more than any other file type, to prepare the image for further use in the future.

RAW data

RAW data is the term given to the basic information provided by a camera or scanner sensor and its software, before that information is processed and saved as a **TIFF** or **JPEG** file. Some people call a digital camera's **RAW** data its digital negative. That sums up its importance, because it contains the original, unaltered information. The benefit to the photographer is obvious – you can use it just as you would revisit a film negative, and you can change what you do with the information. This is particularly important with digital capture: it allows us to go back and do more to the image than we could before. A **RAW** file obviously takes longer to provide an image to work with, as we need to process the data post-capture in computer, so it is not best suited to speed. If you need out-of-camera ready pictures fast, you should use **JPEG** or **TIFF** files. Another feature of **RAW** data is that the file size is smaller than a **TIFF** file as it is not yet processed.

enhance

A camera or digital back manufacturer supplies a program for manipulating its own RAW data. In addition, third-party programs are available in some instances. These may sometimes offer more in key areas than the supplied options. Interestingly, a plug-in for Photoshop allows some work to be done to a RAW file without opening the dedicated manufacturer's software.

So we have the file, the software is open, but what are the key areas to tackle? First may be the

look of an image. This is called rendering, and is similar to an in-camera selection of, say, a landscape, a portrait or a product look. However, here we have the benefit of changing from one to the other. We can produce all if we wish and judge which is the best afterwards. Likewise, adjusting the white balance or even measuring that from a point in the image at this post-capture stage is possible. Selecting colour or monochrome is another

1/ Processing RAW data post-capture allows major aspects to be adjusted such as sharpening and colour. You can also correct any colour cast.

2/ As an alternative to major manipulation programs like Photoshop, many camera manufacturers also offer software with significant adjustment controls.

3/ A RAW data file is your digital negative ready for interpretation.

4/ Batch processing saves the photographer from time-consuming and tedious tasks when dealing with lots of images.

5 colour balance/usm

- ▶ ☒ Curves
- ▶ ☑ Color Balance
- ▼ ☑ Unsharp Mask

RGB, 21 %, 5 %, 0 Levels

Color: [RGB ⬍]

Intensity: ◀ ▭ ▶ 21 %
Halo Width: ◀ ▭ ▶ 5 %
Threshold: ◀ ▭ ▶ 0 levels

- ▼ ☑ Digital DEE

Shadow adjustment ◀ ▭ ▶ 20

[<< Less]

Highlight adjustment ◀ ▭ ▶ 20
Threshold ◀ ▭ ▶ 190

- ▶ Size/Resolution
- ▶ Bird's Eye
- ▶ Information

4 batch

Source

[Hardisk III:Studio 16/10/03:] [Choose...]

☑ Include subfolders
☐ Periodically check for new files in this folder
☐ Delete files from this folder after they are processed

Image Adjustments

○ Apply current settings [Change Settings...]

○ Apply settings in: [_____] [Choose...]

● Apply settings already in NEF files

Destination

☑ Use source folder ☐ Use source file name

Save to: [Macintosh HD:Documents:] [Choose...]

Next file name: [Img0001.TIF] [Edit...]

Save as type: [TIFF Format (RGB) ⬍] [No Compression ⬍]

○ 8-bit ● 16-bit

[Cancel] [Start]

choice. In most programs, the image sharpness can be worked upon with USM controlled in a global or specific way. Individual channels too can be adjusted, as can noise effects, and don't forget to crop the image if necessary. If you have a large number of images from a shoot, then the batch command helps turn these into basic files as desired and places them in a designated location on your system.

5/ RAW files enable sharpening to be set for differing amounts from a zero setting. The best value for an image with several different end uses can be produced.

enjoy

When all adjustments are complete, you get a range of options to change the data into a file format that most applications can read, but you can create a variety of different options if you wish. For high-quality work, RAW files can be produced into 16-bit TIFF files as an alternative to 8-bit TIFF or JPEG files. This has advantages if the software program used to manipulate the image further down the imaging chain, or prepare it for reproduction, can work with 16-bit data. More colour information is available, making results more accurate, but the files will also be bigger.

3 basic post-production

'Terrace' by David Rowley

in this chapter...

Basic post-production methods can help you lift an ordinary or less than acceptable picture into the realms of the artistic image.

brightness, contrast and more

Most digital images benefit from basic adjustments such as brightness and contrast and hue and saturation to make the most of their colours.

pages 44–45

alternate endings

This spread shows how you can take an image that didn't live up to its original brief and transform it into something quite new and different.

pages 46–49

basic retouching

Here, we focus on the simple but fundamental technique of removing blemishes and unwanted features by using the Clone tool. Also covered is how to boost an image taken outdoors by adding a bright sky.

pages 50–51

subtle variations

It's often the case that less is more with digital adjustments, and here we see how small variations in colour balance can have a subtly beautiful effect.

pages 52–53

perfect backgrounds

A good image can be turned into a great image by creating the perfect backdrop to highlight the subject.

pages 54–57

brightness, contrast and more

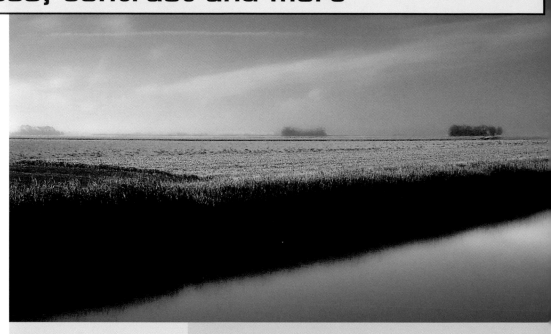

There is often only a small difference between an image that is merely adequate and one that is absolutely right. Brightness and contrast and hue and saturation adjustments are important tools in this aspect of digital image-making. Some images benefit from strong effects, but most work best with just a subtle alteration.

shoot

Allan Schaap is based in the Netherlands. This shot, 'Canal' [1], was captured using a 5Mp compact camera, although Allan now uses a full-frame digital SLR for most of his photography.

enhance

A few adjustments were made to the out-of-camera file. These included increasing the saturation (via Image > Adjustments > Hue/Saturation), and selective area blur using the Gaussian Blur filter (Filter > Blur > Gaussian Blur). Both these adjustments took place in Photoshop. This post-production work took around one hour.

enjoy

Allan has sold this image to local provincial government. For use in this book, the image was supplied as a 5.5MB TIFF file with LZW (Lemple-Zif-Welch) compression applied. This compresses the file size, and is compatible with TIFF, GIF and PDF files. LZW is a lossless method that works best with images that contain a large expanse of a single colour.

> Photoshop
> hue and saturation
> gaussian blur
> TIFF file

! *Brightness and contrast* Most images require some brightness and contrast adjustment. Simple slider controls and on-screen preview boxes will give you a good idea of the changes taking place before you commit to them. However, a proper viewing environment and a calibrated screen are essential if your changes are to be reflected accurately. If you need to sharpen an image, be aware that Unsharp Mask is usually most effective when applied at the end of any post-production work, and that it will change localised contrast levels when applying a new amount of sharpening to an image. Further, more detailed control comes from using Levels and Curves (see pages 62–67).

! *Saturation* We are bombarded with images in advertising and everyday life that have super-saturated colours, and sometimes inaccurate hues. This may be deliberate in advertising, often mimicking what we become accustomed to when viewing TV. Popular film emulsions also feature above-average saturation and subtle hue adjustment compared with real-life colours. Images out of many digital cameras, on the other hand, may look flat and need some help to boost them. Most image-manipulation programs enable you to make such adjustments via sliding levers, although some offer alternative means.

Best results often come from adjusting specific areas of an image, rather than making a global colour correction. Use a selection tool like the Magic Wand or Lasso to define the area you wish to change. Creating a new layer each time, and then for each separate area, enables you to go back and adjust each one again if necessary. This can be important, as changes in one area may make previous adjustments look wrong.

1/ The final image.

2/ Critical control comes from adjusting a specific colour range; in this case, blue. You can also lose specific colour values and reduce parts of an image to monochrome.

3/ Activating the Colorize option enables an overall tone to be applied and adjusted.

4/ Most image-manipulation packages offer easy-to-adjust sliding controls for contrast, brightness, hue and saturation.

5/ Variations in Photoshop allows you to adjust only the saturation globally if you wish, by displaying alternative values to those currently set. If the Clipping box is checked, you get a warning of changes out of gamut for a specific range of colours. Here it is the working CMYK profile Euroscale Uncoated v2. This means that the colour values you will be setting cannot reproduce as such when the image is converted into the specified profile.

Be careful while retouching. The best retouching goes unnoticed.

alternate endings

One of the most rewarding aspects of digital control is that it enables less-than-perfect images to be turned into something more exciting. 'Through The Pines' is a good example of this. It pays to think about what alternatives you could produce from a disappointing image before deleting it permanently.

shoot

Felipe Rodriguez, who is based in Seville, Spain, used a 5Mp compact SLR to take this shot. It was initially conceived as a digital infrared image, so an appropriate deep red filter was attached to the lens [1]. This resulted in a 1/2 sec exposure time even though the aperture was a mid f/5.5 value at the set 100 ISO sensitivity. The result was disappointing, but Felipe's Photoshop skills came to the rescue.

2 channel mixer

Output Channel: Gray

Source Channels

Cyan: +100 %

Magenta: 0 %

Yellow: 0 %

Black: 0 %

Constant: 0 %

☑ Monochrome

OK
Cancel
Load...
Save...
☑ Preview

enhance

It was decided to recolour parts of the image in different ways. First, the whole shot was stripped of its colour via the Image > Adjustments > Channel Mixer > Monochrome menus [2]. This gave a flat-looking result [3], so Levels (Image > Adjust > Levels) were adjusted to put some contrast back into the shot. Next, various selections were made, mostly using the Lasso tool. Using a separate layer for each area, the colour and contrast were adjusted after using the colour balance control [4/5/6/7] to neutralise the tones. A graphics tablet and pen comes in handy for this kind of work, where precise selection is a must. Then the layers were flattened. Manually recolouring is very time-consuming, and Felipe spent five or six hours working on this image.

> Photoshop
> TIFF
> channel mixer
> levels
> lasso tool
> layers
> colour balance
> flatten layer
> levels
> web

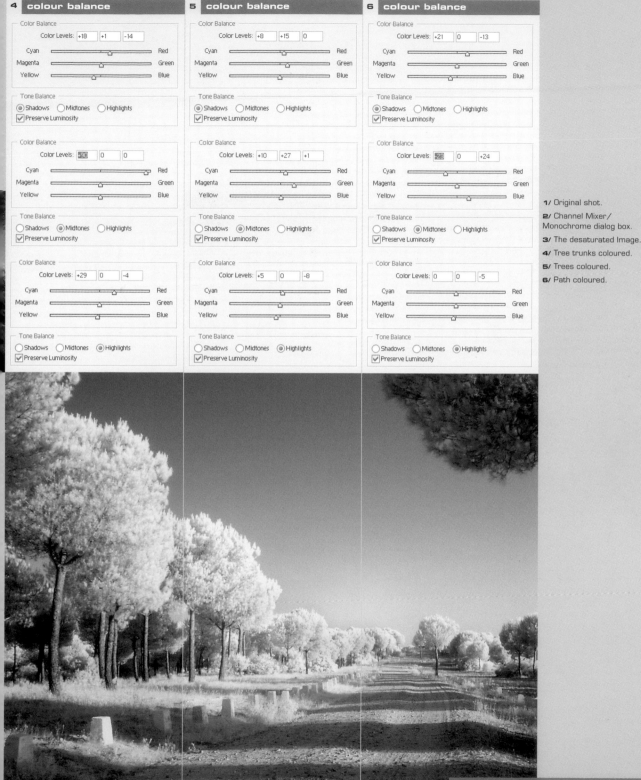

4 colour balance

Color Balance
Color Levels: +18 +1 -14

Cyan ——————————⊓———— Red
Magenta ———————⊓———————— Green
Yellow ———————⊓———————— Blue

Tone Balance
◉ Shadows ○ Midtones ○ Highlights
☑ Preserve Luminosity

Color Balance
Color Levels: -50 0 0

Cyan ————————————————⊓— Red
Magenta ———————⊓———————— Green
Yellow ———————⊓———————— Blue

Tone Balance
○ Shadows ◉ Midtones ○ Highlights
☑ Preserve Luminosity

Color Balance
Color Levels: +29 0 -4

Cyan ——————————⊓———— Red
Magenta ———————⊓———————— Green
Yellow ———————⊓———————— Blue

Tone Balance
○ Shadows ○ Midtones ◉ Highlights
☑ Preserve Luminosity

5 colour balance

Color Balance
Color Levels: +8 +15 0

Cyan ——————————⊓———— Red
Magenta ———————⊓———————— Green
Yellow ———————⊓———————— Blue

Tone Balance
◉ Shadows ○ Midtones ○ Highlights
☑ Preserve Luminosity

Color Balance
Color Levels: +10 +27 +1

Cyan ——————————⊓———— Red
Magenta ———————⊓———————— Green
Yellow ———————⊓———————— Blue

Tone Balance
○ Shadows ◉ Midtones ○ Highlights
☑ Preserve Luminosity

Color Balance
Color Levels: +5 0 -8

Cyan ——————————⊓———— Red
Magenta ———————⊓———————— Green
Yellow ———————⊓———————— Blue

Tone Balance
○ Shadows ○ Midtones ◉ Highlights
☑ Preserve Luminosity

6 colour balance

Color Balance
Color Levels: +21 0 -13

Cyan ——————————⊓———— Red
Magenta ———————⊓———————— Green
Yellow ———————⊓———————— Blue

Tone Balance
◉ Shadows ○ Midtones ○ Highlights
☑ Preserve Luminosity

Color Balance
Color Levels: -23 0 +24

Cyan ——————————⊓———— Red
Magenta ———————⊓———————— Green
Yellow ————————————⊓—— Blue

Tone Balance
○ Shadows ◉ Midtones ○ Highlights
☑ Preserve Luminosity

Color Balance
Color Levels: 0 0 -5

Cyan ——————————⊓———— Red
Magenta ———————⊓———————— Green
Yellow ———————⊓———————— Blue

Tone Balance
○ Shadows ○ Midtones ◉ Highlights
☑ Preserve Luminosity

1/ Original shot.

2/ Channel Mixer/ Monochrome dialog box.

3/ The desaturated Image.

4/ Tree trunks coloured.

5/ Trees coloured.

6/ Path coloured.

enjoy

Color Balance

Color Levels: -3 0 +23

Cyan —————————————— Red
Magenta —————————————— Green
Yellow —————————————— Blue

Tone Balance

○ Shadows ○ Midtones ○ Highlights
☑ Preserve Luminosity

Color Balance

Color Levels: 23 0 +24

Cyan —————————————— Red
Magenta —————————————— Green
Yellow —————————————— Blue

Tone Balance

○ Shadows ● Midtones ○ Highlights
☑ Preserve Luminosity

Color Balance

Color Levels: -9 0 +16

Cyan —————————————— Red
Magenta —————————————— Green
Yellow —————————————— Blue

Tone Balance

○ Shadows ○ Midtones ● Highlights
☑ Preserve Luminosity

This image resides on the photographer's website. He hopes that it will become a print that he can sell commercially. An alternative version was also made, using a further small Levels amendment to add contrast before resizing it for viewing on the web.

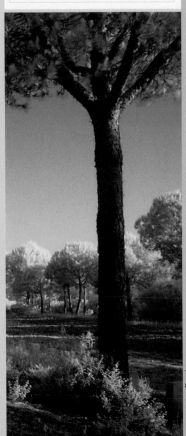

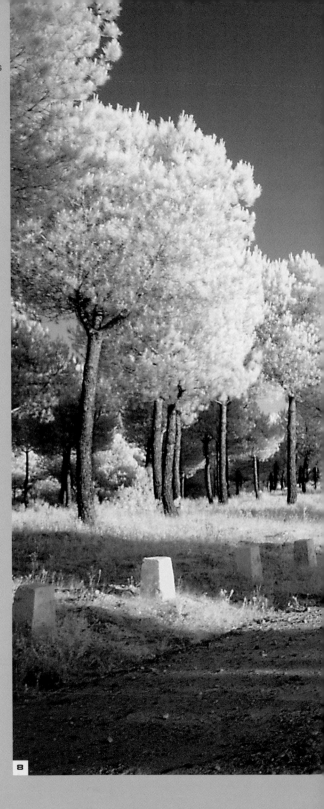

7/ Sky coloured.

8/ The final image.

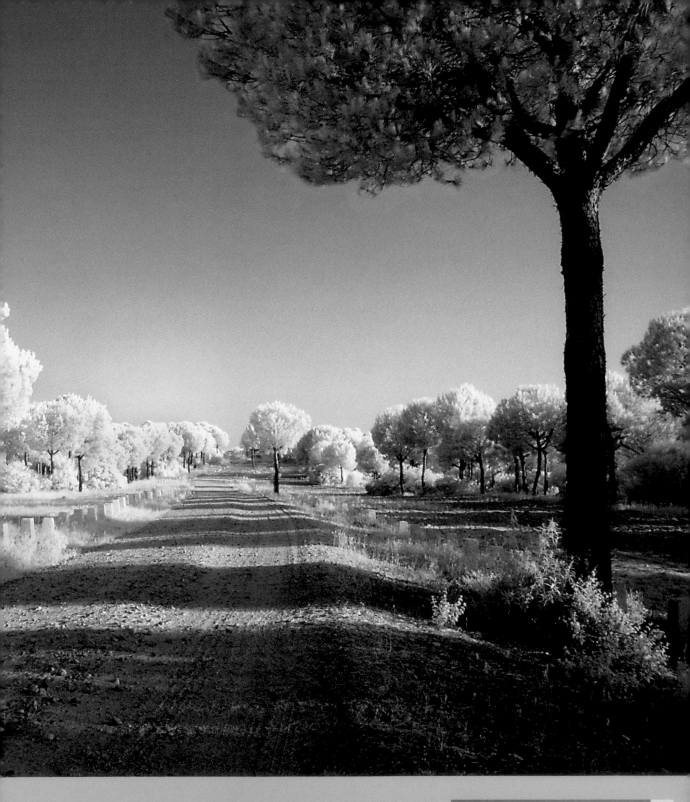

Jon Bower's travels take him all around the globe, although part of this image, 'Penguin At London Zoo', was shot in his home country of the UK. Jon shoots 35mm transparencies before scanning them into the digital domain, ready for post-processing, archiving and use. While he sometimes preconceives an idea, often the approach that he finds works best is to take a shot with potential, and then see where the post-capture manipulation can take it. This results in some memorable, but realistic, montages.

basic retouching

'The daft expression on this young penguin amused me, but the background was awful. So I shot the image, knowing the background would go, and framed accordingly.'

enhance

The two images [1/2] were scanned at 4000dpi in a dedicated 35mm film scanner. Jon is meticulous about removing dust in the results and undertakes painstaking de-spotting in Photoshop. The Clone tool and Healing brush are invaluable for this. Jon switches between the two tools depending on the size of spot, nature of blemish and characteristic of background being worked on. The penguin shot was adjusted using Curves and Levels to get the maximum detail and best contrast. Then came the difficult task of extracting the foreground and penguin – tricky because of the hairy outline of the subject – and the removal of the drab concrete background. Jon first made a rough outline with standard selection or magnetic tools; he then went into Quick Mask. A selection of brushes used at different opacities, from coarse to fine, with painting at pixel level with black or white got the selection right. Finally, a touch of feathering completed the task.

The penguin was pasted into an image of a blue sky taken in Bali. Gaussian blur was applied to produce a realistic out-of-focus effect using a maximum 15-pixel radius. This was enhanced with small amounts of blur added to other elements. To make the foreground colour temperature look right, the image was adjusted using Colour Balance (Image > Adjustments > Colour Balance) [3] as it looked too blue. The image was also flipped from left to right for visual balance. Then the layers of these stages were flattened. It took about two hours in post-production to achieve the final result [4].

> 35mm film capture

> scan

> Photoshop

> layer

> clone tool/healing brush

> layer

> levels/curves

> layer

> magic wand

> quick mask

> painting

> layer

> feathering

> cut/paste

> layer

> gaussian blur

> layer

> colour balance

> flatten

> CD

> web

1/ The initial image was captured with a fast-aperture 70–200mm lens.

2/ A shot from the other side of the world supplied the desired bright sky.

3/ Colour Balance was used to tone down the blue sky.

4/ The final image.

3 | colour balance

Color Balance
Color Levels: 0 0 -3
Cyan — Red
Magenta — Green
Yellow — Blue

Tone Balance
○ Shadows ● Midtones ○ Highlights
☑ Preserve Luminosity

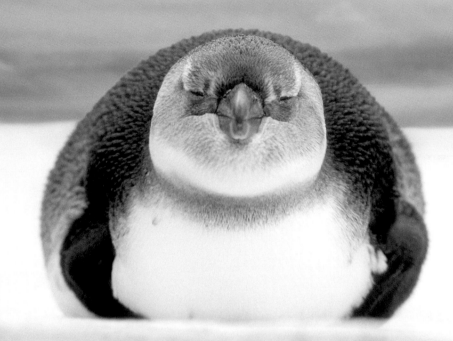

This image was archived to CD. Jon sometimes makes prints for personal use, but most of his images are sold to magazines, books or online image brokers such as Alamy.

! Cloning is one of the most useful tools available to the digital photographer. Whether you want to create a new, unblemished area of a subject; extend or contract a desired part; or clone for special effects, cloning is a fundamental technique to master. The Clone tool, or Rubber Stamp tool, as it is also known, is often best used with a brush size and shape that is a little larger than the area you wish to cover.

Setting to 'aligned', and clicking onto the area to be copied while holding down the Alt key allows the target area to be covered by clicking over it and dragging. The new image is slowly copied over the top of the old one. You can move the cursor elsewhere and the clone will continue from where it left off. If 'non-aligned' is set, each time you move to a new part of the image to clone, a further selection is needed by clicking the mouse, otherwise the last sampled point starts again.

! When cloning, do the minimum necessary and know when to stop.

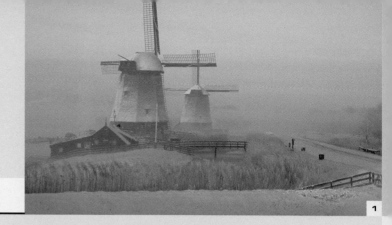

! Remove (small) items in an image that distract attention away from the main subject by using the Clone tool.

subtle variations

Most images benefit from some adjustment of brightness and contrast once downloaded onto the computer. Jaap Hart's 'Winter in Holland' is a fine example.

shoot

A manual-exposure 35mm camera made in the 1970s still serves Jaap well, in this case with an 85mm f/1.8 lens attached. The original shot [1] was taken using colour slide film at about 8:30 one Sunday morning in the Dutch town of Schermerhorn. It had snowed the night before and Jaap wanted to capture the occasion. It was just as well he did, as no more snow fell that year. There are seven windmills located within one kilometre of the town; three are close to each other along the Noordervaart (the road on the right), and the image shows the view towards the two most westerly ones. A beautiful ground mist covered the landscape, almost obscuring the farmhouses and trees in the background. The bright sun gave the scene further character.

enhance

The image was scanned onto a Kodak Pro Photo CD at a resolution of 3072 x 2048 pixels. With 24-bit colour per pixel, this resulted in 16 million colours and a 24.7MB file. The image was saved as a lossless TIFF file.

The distracting features of a car next to the windmill in the background, trashcans along the road and a flagpole in front of the first windmill were removed using the Cloning tool. The colour balance was altered towards yellow/red, helping to 'warm' the image [2]. Using Paint Shop Pro and with the help of the histogram, brightness (+12) and contrast (+9) were increased [3]. Jaap then smoothed the sky and mist using the Edge Preserving Smooth command. This removes noise in an image by smoothing areas between the edges of objects but not the edges themselves. This command is also useful for smoothing out blotchy complexions, and has the added benefit with film images of reducing the effect of grain. In all, the work took about two hours to complete.

2 hue/saturation

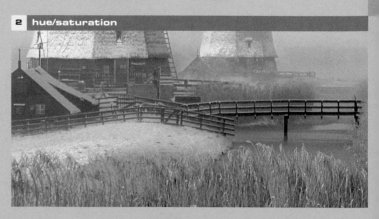

> 35mm film capture

> scan

> photo **CD**

> clone tool

> colour balance

> histogram

> brightness

> contrast

> edge preserving smooth

> ink jet

> web

! Brightness and contrast can be adjusted globally or to specific, pre-selected areas. The latter option gives you great flexibility to create an image with depth. If you are producing your own ink jet or dye sub prints (see pages 94–95), it is best to turn off any printer software that may adjust the image when you have a properly calibrated monitor or you may get different results from what you expect.

! You can save time and money by doing a test print before making a full print. Cut and paste small, important areas onto a single sheet of paper, using different amounts of adjustment so that you can check the results.

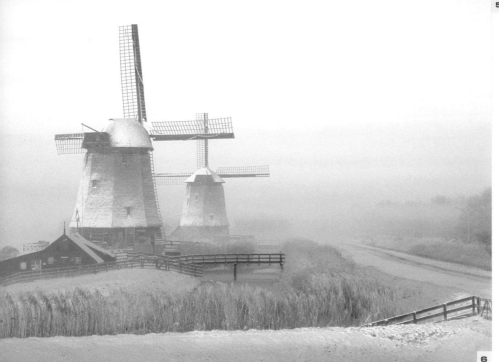

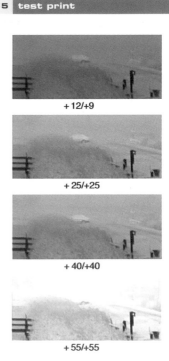

5 | **test print**

+12/+9

+25/+25

+40/+40

+55/+55

6

3 | **brightness/contrast**

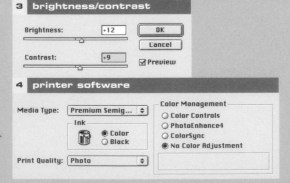

1/ The original image.

2/ The colours were 'warmed' slightly to enhance the image.

3/ Most applications offer a sliding control to adjust the basics of brightness and contrast.

4/ Using Colorsync or equivalent is beneficial if accurate colour is needed. If not, consider turning off printer software when working with a calibrated monitor.

5/ Consider creating a test print to save paper costs.

6/ The final image.

Brightness: +12 OK
Cancel
Contrast: +9 ☑ Preview

4 | **printer software**

Media Type: Premium Semig...
Ink
○ Color
○ Black
Print Quality: Photo

Color Management
○ Color Controls
○ PhotoEnhance4
○ ColorSync
● No Color Adjustment

enjoy

Jaap makes prints mostly for his own enjoyment. On the web, files are resized to the appropriate requested size.

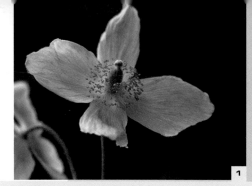

1

perfect backgrounds

Often the best image comes as a result of getting not only the subject right, but the background as well. It may be a subliminal aspect in many cases, but with digital techniques, there is no excuse for a dull backdrop.

shoot

Taken by Phil Preston at the Royal Botanic Gardens in Kew, England, this image started life on 35mm film. He used an SLR fitted with a 100mm macro lens. The original shot [1] had an uninspiring background, plus a distracting flower in the bottom left corner, so it was deemed ripe for post-production. To digitise the image, it was scanned at 2700dpi to produce a file of about 20MB.

2 fill gallery

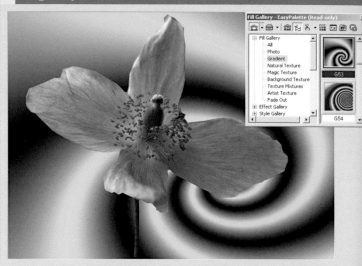

enhance

Phil used PhotoImpact software to add a new spiral and a two-colour gradient background, with some blur and lighting adjustments to highlight the central flower petals. Similar enhancements can be made in other photo-editing programs. After opening the original file, the first step was to select the poppy ready for manipulation. This was done by clicking on the Lasso selection tool, found on the tool panel, and choosing Soft Edge number 3. A careful movement around the flower petals and stem was then made. Double-clicking the mouse when back at the starting point completed the selection. At this stage, it is the flower rather than the background that was selected, so Phil used the Invert command on the toolbar to make the background the active area instead.

A new background was added by clicking View > Toolbars > Panels > EasyPalette. This

brought him to the Galleries icon. Phil selected Fill Gallery > Gradient and scrolled down to Spiral 3, choosing this as a gradient to show in the image background by double-clicking onto it. However, the default colour was not suitable (2), so Phil changed it by selecting the Linear Gradient Fill tool, and setting Fill Method for Two Colours (3). He then clicked the Fill Colour boxes and selected his choices.

Understandably, Phil finds that complementary colours work well with this kind of image. In this example, dark blue (Hex No. 563CFF) and pale lavender (Hex No. B3C7FF) were used. By setting Merge Method to Hue and Saturation, and then Transparency to 0, Phil dragged the Fill tool from the bottom left corner to the top right of the new background. The spiral colour changes to a gradient fill based on the two selected colours on releasing the mouse.

Darkening the spiral background helped to highlight the flower petals. This was achieved by selecting Format on the standard toolbar, then Brightness and Contrast. In the dialog box that appears, Gamma was reduced from 1.00 to 0.50, darkening the background and making the spiral shape more pronounced (4). Phil then decided to add some Gaussian blur to the outer part of the petals. The

Lasso tool was chosen again and set to a Soft Edge of 100. The central part of the flower and other areas of the petals meant to remain in focus were selected, and then the image was inverted again so the other parts could be defocused slightly. This was done with 'new layer' object selected before inverting. With the new layer active, Effect on the standard toolbar reveals the blur options available.

4 brightness/contrast

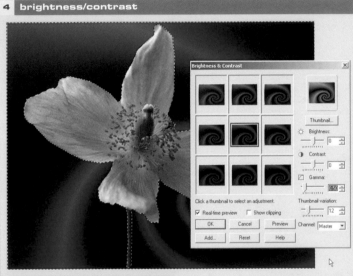

3 linear gradient fill

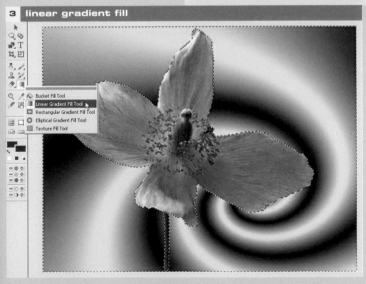

1/ The original image.

2/ The spiral background was selected from the Fill Gallery options.

3/ The default colours were changed to ones of the photographer's choice.

4/ Brightness and contrast adjustments were made to darken the background.

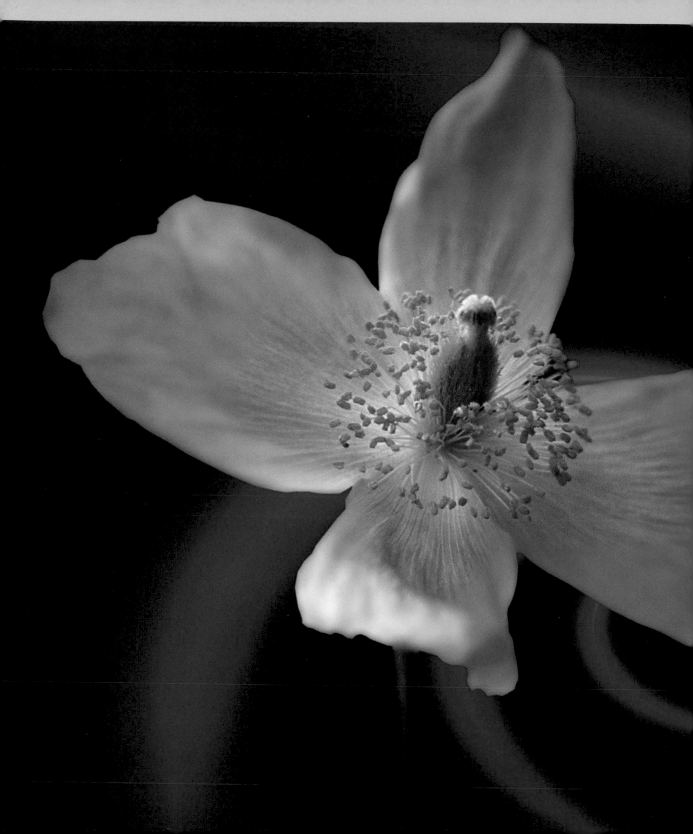

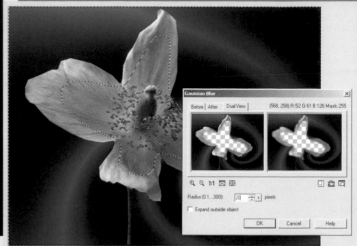

6

From here, Sharpen > Gaussian Blur was selected. The parameters were adjusted with Variance set to 20 (5). All layers were then merged by selecting Merge > All. In Photoshop, an unflattened PDF file allows layers to be accessed again; in PhotoImpact, this is achieved by saving in the 'UFO' format.

A new lighting effect was then introduced to highlight the central part of the poppy and to darken the background further. Effect > Magic > Light > Options was the route taken, applying the following settings: exposure = 80%, ambience = 50%, light = 100%, skew = 0, spread = 11, distance = 300, and elevation = 90. The last step was to increase saturation slightly, by clicking Format on the standard toolbar and choosing Hue and Saturation. The latter was increased to +15. The image was then saved as a TIFF file.

enjoy

This has proved a popular image and has been reproduced in photography magazines. At 3000 x 2298 pixels, the image would easily print to around 10 x 7 inches at 300dpi.

5/ Some Gaussian Blur was added to the outer edges of the petals.

6/ The final image.

4 artistic post-production

'Sampan' by Paul Aylett

in this chapter...

In this chapter, we concentrate on the more advanced and sophisticated post-production techniques that are used to transform images in line with the photographer's creative vision.

adjusting curves

In this section, we look in detail at using the Curves feature to adjust an image's tonal contrast.

pages 62–65

adjusting levels

Levels adjustment is another effective method of altering tonal contrast to maximise artistic effect.

pages 66–67

setting a white point

Setting a white point is a very useful way to remove unwanted colour casts from an image.

pages 68–69

setting a black point

Here, we look at setting a black point in order to enhance contrast and boost a picture's impact.

pages 70–71

step by step

Sophisticated tools such as layer masks and the Liquefy feature are valuable ways to make adjustments to images created from several elements.

pages 72–75

subtle adjustments

Sometimes small touches are all you need to dramatically enhance an image. Here, we look at feathering selections and auto colour correction.

pages 76–77

building an Image

Here we examine the use of Layers – one of the most useful tools at our disposal when working on complex images.

pages 78–81

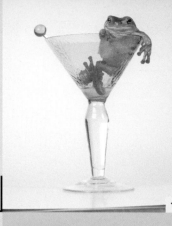

'We own five pet frogs that we like to use for silly photos. We had the idea of a frog in a glass, and Olive, our White's Tree frog, is so laid back she just sits wherever you put her. We placed her on the lip of the glass and she hung there with that goofy look on her face. We just snapped the picture.'

1

adjusting curves

When time and circumstance allow, images often benefit from individual enhancement to key areas. If you use the right digital tools, such as Curves, this is easier and more controllable than ever and well worth the effort. Such close attention to detail helps create the innovative results demanded in professional stock photography.

shoot

This image, 'Frog in a Martini Glass', was captured on medium-speed 100 ISO transparency film, using a professional 35mm SLR and 100mm macro lens (1). The photographers were Canada-based Anita Dammer and Darwin Wiggett, who shot the image for their stock portfolio. It was lit by two studio lighting heads, each fitted with a softbox.

enhance

As simple as the set-up seemed, there was plenty of work to do to achieve the optimum result. The image was first scanned using a professional desktop unit, one that approaches the quality of a drum scanner. Then the image was cleaned up by removing dust marks. This procedure, like the rest of the manipulation, was carried out in Photoshop. The

white backdrop was cloned onto the grey area, and the image cropped to remove the bottom brown line (2). The background was then selected, and turned pure white by using the white Eye Dropper tool (see pages 68–69). When you do this, the RGB channels individually read as a pixel value of 255 – the brightest they can be. The photographers

2 crop

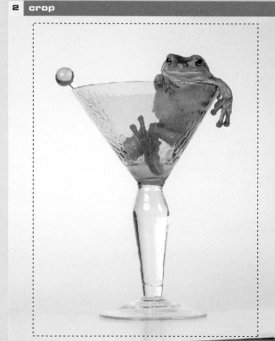

1/ The original image.

2/ Cropping the image.

3/ Adjusting curves to improve contrast.

4/ Plotting a curve for a more specific tonal adjustment.

> **35mm film capture**
> scan
> **Photoshop**
> clone
> crop
> background selection
> white eye dropper
> curves
> clone
> colour adjustment
> hue/saturation

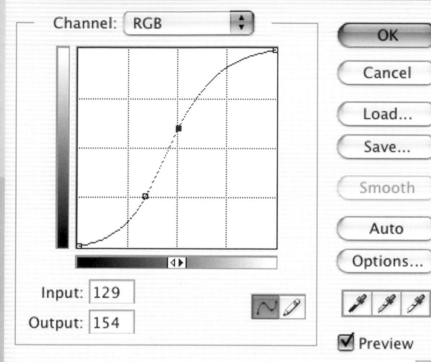

Channel: RGB

OK
Cancel
Load...
Save...
Smooth
Auto
Options...

Input: 129
Output: 154

Preview

! While Levels are a wonderful way to adjust shadow, midtone or highlight values, Curves enables any pixel to be changed across the full 0–255 scale. In addition, Curves allow individual colour channels to be altered. Curves are a precise way to modify an image. An S-shaped curve, for instance, can adjust the highlight and shadow pixels, but leaves the midtones unchanged. The look retains a sense of reality, but the extra contrast adds impact to the image.

also use Curves (Image > Adjustments > Curves) on all images to improve contrast. An S-shaped curve (3) will brighten highlights, but also darken shadows, and this is a useful method to use when the original has a wide tonal range. However, this type of curve will not modify the midtone values and adds a further level of impact that remains natural-looking.

The reflections in the stem of the glass were then subdued, as was a red colour cast on part of the frog's stomach. Saturation was increased in the key areas of the green skin and the yellow in the eyes. The highlights in the eye were then also brightened for the same effect. In total, this took around one hour's work.

! Rather than using Hue and Saturation controls to globally correct an image, select individual components, then alter the hue and saturation in those areas, such as the eyes, the glass and the frog in this shot. Layers or a similar feature are useful in combination for this.

! Plotting a curve can be useful when you wish to work on a specific area. Lock points by holding down the control key and clicking onto the scale. Here, the shadows and highlights have been locked with numerous points, but the midtones can still be changed. With too few locking points, strong changes to midtones could still affect the darker and lighter areas as the curve is adjusted.

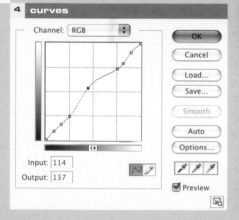

Channel: RGB

OK
Cancel
Load...
Save...
Smooth
Auto
Options...

Input: 114
Output: 137

Preview

A Curve shows intensity from left to right as pixel values 0 (black) to 255 (white) for the original (input) image. The vertical scale on the left shows the adjusted (output) values. The escalating diagonal line first seen therefore represents pixels starting at the shadows, rising through midtones and ending as highlight details. At this stage, it is a straight line as no adjustments have been made (5). A step wedge scale also sits along the left to help gauge where you are adjusting the values. Clicking into the image with the cursor shows the current pixel value. If you click onto the line and drag it, you move that pixel value to another brightness, and the comparison is shown in the output and input dialog boxes. As you do so, the image will change to show the effect. Moving a pixel upwards increases brightness; moving it downwards decreases it. Curves works with both **RGB** and **CMYK** images (6). In both instances, the scale works as pixel brightness

values 0 to 255, or, if you prefer, in percentage from 0 to 100. You can change this back and forth by clicking the step wedge scale along the base. Further control comes from working in a specific colour channel, selected from the drop-down menu. This can be useful to adjust a colour cast in the whole image or specific areas or to make other colour adjustments.

! If you wish to remove a point that you have set, drag it outside the preview.

enjoy

The image was made for the photographers' stock agent (www.firstlight.ca).

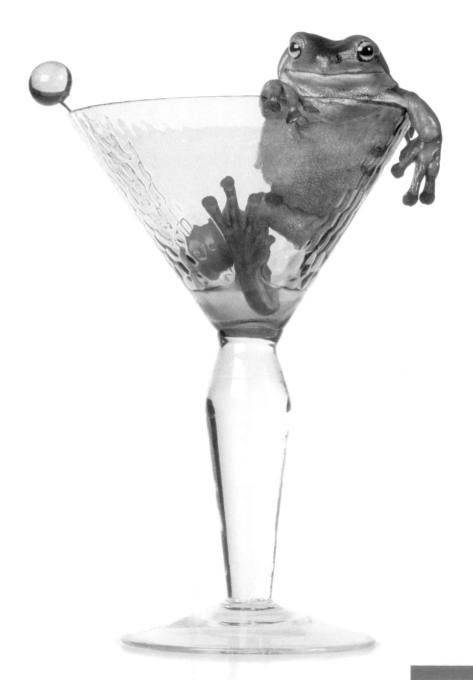

5/ Curves with no adjustments made.

6/ Using Curves with a CMYK image.

7/ The final image.

7

1

Working in the channels A more precise levels adjustment is sometimes necessary. The ability to change brightness of pixels within different **RGB** or **CMYK** channels is to be appreciated. At its most basic, this becomes another way to distort the colours in an image, often making something tame and lifeless more dramatic and surreal.

adjusting levels

You can use Levels to adjust the contrast of an image or to modify its tonal range. Levels can also be corrected with particular effect as an adjustment layer if, for instance, you are working on component parts of a complex image, or trying out different effects. Adjusting levels is a common aspect of image manipulation, particularly at the onset with digitally captured files, but also when a scan has not created the desired tonal range. Levels in Photoshop, for example, is grouped with other popular options under the Adjustment menu (Image > Adjustment > Levels).

shoot

Walter Spaeth's 'Flow' is a typical example of the importance of levels adjustment. The original nude study was shot on location in an old barn. Walter employs both film and digital capture, but increasingly uses the latter on a digital SLR with a wide range of focal lengths, from 24mm to 400mm. His camera uses a sensor smaller than full-frame, so he chooses the best focal length with the 1.5x magnification factor in mind.

enhance

The original shot was too dark, so levels were adjusted by moving the white arrow towards the base of the histogram curve. This brightened the image. Next, the red channel was selected. The image was converted to greyscale, then converted back to RGB mode as a separate layer. A sepia tone was created and a plug-in used to provide a texture overlay. A final touch was to use another plug-in to blur the image slightly. In all, around two hours were spent working on this image.

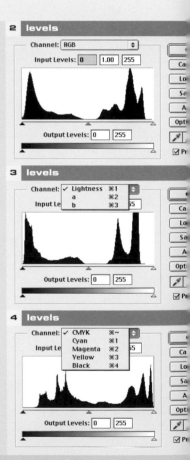

enjoy

A specialist printing company produced this image as a limited edition of ten 60 x 40cm prints using the Giclee process (see page 96). Walter also uses a desktop ink jet printer to make his own prints of up to A3 size. He uses pigment inks and either watercolour or high-gloss photopaper.

> Photoshop
> levels
> greyscale
> RGB
> layer
> sepia tone
> texture
> giclee print
> watercolour print
> gloss print

1/ The original image.

2/ 3/ 4/ Levels can be adjusted within the component colours of an image. It's a feature that's great fun to play with.

5/ The final image.

! With the Levels dialog box open, the distribution of brightness values across pixels can be seen on the histogram. On the left is black (0), while 256 levels brighter is white (value 255) at the opposite end of the scale. Each has an adjustment triangle underneath. Sliding these forces more pixels to become black or white, and hence increases contrast. This makes more grey values one or the other. The mid triangle represents a mid-grey tone, and starts with a value of 1 representing the normal gamma.

This mid-grey tone stays at this setting of 1 unless reset to a new value even though it moves in relation to the other triangles. It therefore maintains a constant midtone brightness value, regardless of position, unless the gamma is changed. A change above a gamma of 1 brightens the midtones, but not the extremes, while lowering below the gamma value of 1 darkens only the midtones. A less often used control is that of output. This enables the 256 range of pixel brightness to be reduced or 'clipped' to a smaller number. In this case, it will reduce the contrast of an image, as there will be no black or white brightness levels. This can be seen on the step wedge scale. This is useful if an image is very high in contrast and you need to maximise midtone detail.

5

'The white Eye Dropper is excellent for producing the desired clean backdrop in the studio'.

setting a white point

1

7

Much professional product and people photography is shot against a white backdrop, making it easier for the desktop designer to cut out the image and place or drop it against an alternative background. But achieving a white or plain backdrop in the studio is not always a straightforward task.

> JPEG
> Photoshop
> white point
> white point 2
> clone tool
> global USM
> crop
> magazine repro
> CD
> ink jet print

shoot

This shot was taken for a photography magazine that had asked me to test a digital SLR. I wanted to obtain a clean white backdrop. Usually, in order to achieve this, I set up two studio flash heads to light the backdrop evenly.

With digital capture, that means having these lights set two stops stronger than the main light. But I got the coverage wrong, and although using a large softbox to the front and above the subject for the main light worked well and provided a soft lighting effect, the

backdrop was not 'clean'; it had a warm colour cast in places (1). However, it was not a major problem to correct this with digital tools in computer.

2 levels

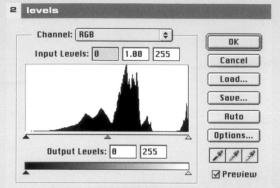

enhance

Opening the image with Photoshop's Levels (2) (Image > Adjustments > Levels), I used the white Eye Dropper tool to click on the resulting orange background. This changed most of the background to the desired white (3), adjusting it to the maximum pixel brightness of 255. But some subtle shades of orange could still be seen in parts, so a second white point selection over one of these corrected the remaining cast (4). Not even professional models have perfect skin, so I used the Cloning tool to remove some blemishes and a strand of hair across the model's face. Finally, the image was cropped and globally adjusted for its USM.

3 white point

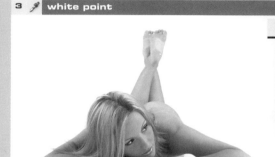

4 white point again

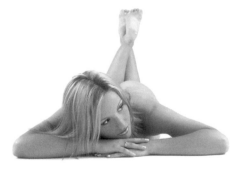

enjoy

The image was saved onto CD and sent to a magazine for reproduction at 300dpi. It was also turned out as A4-size proof prints on an ink jet printer in order to check the image. For this, I used the printer company's premium gloss photo paper.

1/ The original image.

2/ The Levels histogram of the original image.

3/ A white point was chosen for the backdrop.

4/ A second white point measurement was used to clean up a remaining subtle orange cast in some areas.

5/ The Levels dialog box of the corrected image.

6/ The Levels Info window showing that the white backdrop has been placed onto the brightest possible level of 255.

7/ The final image.

5 levels

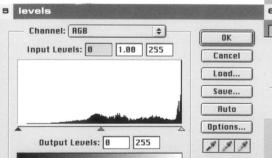

6 levels

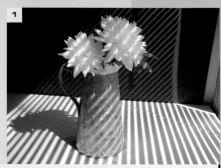

! **Open the Info window (Window > Info) in Photoshop to determine the darkest point values (or the brightest should you wish to find the white point) if it is hard to assess this just by eye.**

setting a black point

Setting a black point means obtaining a true black. This can anchor an image, boosting the contrast and giving it more impact. Setting a black point involves choosing pixels in your image that will have zero brightness.

shoot

Although Sharon Smith uses a 6Mp SLR for much of her still-life photography, she used a 2Mp compact camera for this shot (1). She placed a couple of chrysanthemum cuttings in a vase with the intention of photographing them using window light; before raising the blinds, she noticed the interesting striped pattern across both the flowers and the background.

enhance

The image was initially cropped using the Crop tool in Photoshop. Extra stripes across the table were then cloned (using the Clone tool in Photoshop) to tidy the image and lose some of the shadow area created by the flowers (2). A slight Unsharp Mask (USM) was then applied globally. This was not enough to enhance exactly what the photographer wanted, so further sharpening was applied to the vase and

flower after first selecting around each with the Magic Wand tool. To anchor the image to the shadow detail, Levels were opened in Photoshop (Image > Adjustments > Levels) and the black point set (3). This forced the chosen pixels to zero brightness, thereby guaranteeing a true black that added contrast to the whole image. In total, Sharon spent around forty-five minutes working on this shot.

2 clone tool

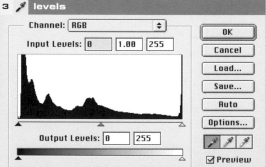

3 **levels**

> crop
> clone
> global USM
> selective USM
> levels
> black point
> curves
> resize
> web

1/ The original image.

2/ The Clone tool was used to enhance the diagonal light and reduce the mass of shadow.

3/ Using the Eye Dropper tools greatly enhances control over image contrast.

4/ The Info window allows a precise assessment of brightness values.

5/ The final image.

4 info

! In the case of this image, setting the black point adds a sense of depth that is aided by the diagonal shadows. Opening Levels in Photoshop shows three Eye Dropper tools: one for the black point; one for the mid point and one for the white point. Clicking onto any point in the image after selecting the black dropper sets those pixels to zero brightness. Most often, the darkest values are the best to choose because it is usually the darkest area that you will want reproduced as black. However, if you want to change other, darker, tones to black too then select the brightest of these. All the tones darker than those selected will automatically fall to black as well.

enjoy

Most of Sharon's photography is displayed on various websites and this one has been very popular – it won Best of Category and a Grand Prize honorable mention on the Digital Photo Contest website. To prepare the image for the web, Sharon resized it to 480 x 640 pixels before sharpening and adjusting curves.

'We thought it would be funny to have a dog bring the remote to his master – especially if the TV show were about cats! So we found the dog model and shot the idea.'

step by step

Anita Dammer and Darwin Wiggett of Natural Moments Photography combine technical and artistic skills with a wonderful touch of humour. This image is an excellent example. It shows how many successful photographs tell their own story: attention to detail is the key.

shoot

These photographers use both digital and film capture; in this instance, the component parts of the image were shot on film (1/2/3). A 100 ISO negative emulsion was used for the shot of the dog, while the cat was captured with a fine-grained, vibrant colour transparency of 50 ISO. Both shots were recorded with a pro 35mm camera. For the dog shot, Anita and Darwin used a wide-angle 20mm lens and two studio flash units with umbrellas fitted to soften and spread the light. The cat was recorded with the same camera, with a 100mm macro lens and hotshoe flash fitted for outdoor fill-in.

1/ **2/** **3/** The component shots.
4/ Liquefy dialog box.

enhance

Both images were scanned with a high-quality desktop scanner and taken into Photoshop. Dust was removed from the dog image using the Clone tool and Healing brush. Then the image of the TV remote was scanned, placed into the image of the dog as a layer, and rotated to the correct angle for the dog's mouth. A small soft-edged brush and a layer mask was then used to paint away sections of the remote so it looked as if the dog was holding

> 35mm film capture
> scan
> clone
> layer
> rotate
> layer mask
> drop shadow
> liquefy
> opacity
> white eye dropper
> black eye dropper

'All our montage work is done with layer masks. We feel layer masks are one of the most powerful tools in Photoshop, and we use the feature whenever we do montages.'

! It is always best to get the shot in camera rather than trying to merge elements together in image-editing software. Capture in camera always looks more real than pasting elements together later.

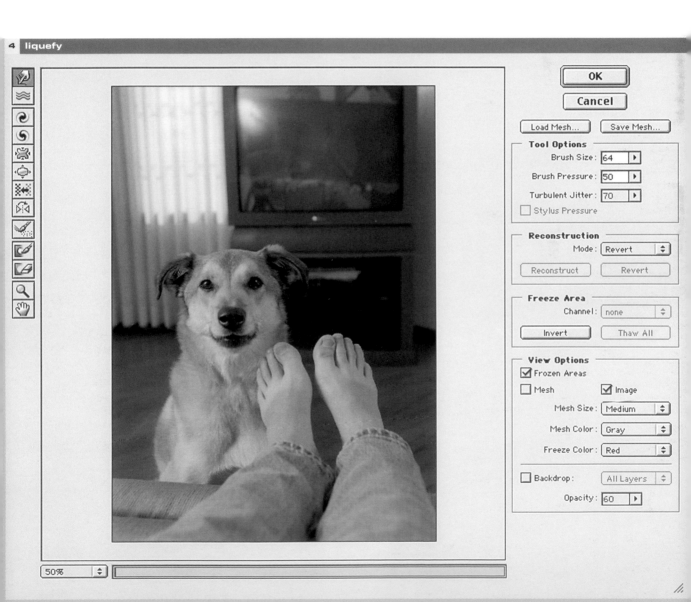

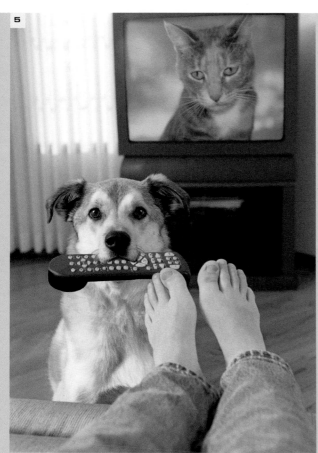

5

Liquefy tool (4) was used to change the shape of the dog's mouth and nose, helping the image look even more convincing. The Liquefy command was also used to help 'bulge' out the dog's eyes.

Now the cat image was placed over the TV, after being sized to fit the screen. This layer was faded back to about 60% opacity, reducing the glare of the glass. Interlaced TV scan lines were added to the TV screen – a small, even subliminal, touch that made the effect more realistic. Next, the white and black Eye Dropper tools in Levels were used to set white and black points in the image. This helped to colour-correct the shot. A black-and-white version of the image was created by using the Calculations command in Photoshop and combining 60% red and 40% green in the appropriate channels. Next, the highlights were toned, turning them brown using the Hue and Saturation control. The shadows were toned blue using the same method. Finally, an edge effect was added using PhotoFrame software. Not surprisingly, given the complexity of the concept, around four hours were spent post-capture creating this image.

it in his mouth. Making this look realistic was a painstaking process. A drop shadow was placed around the dog's mouth to help the effect. Then the

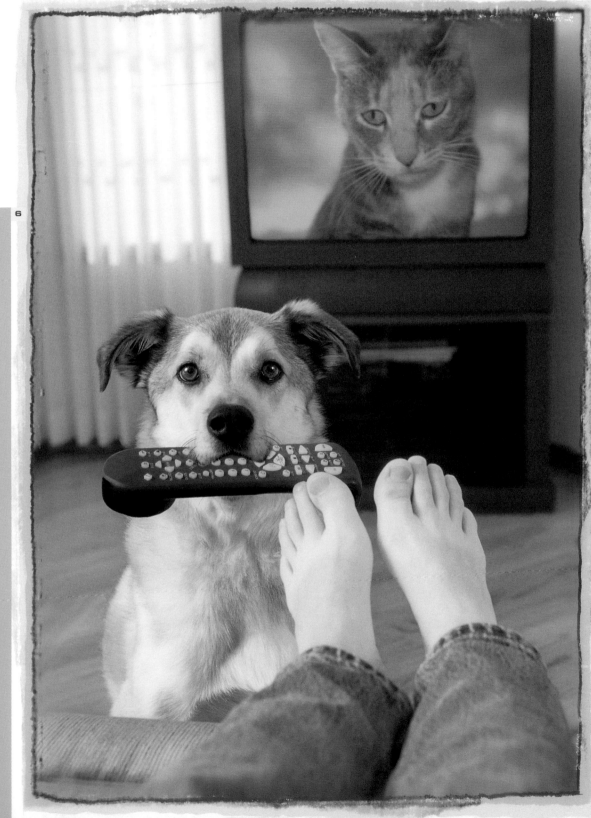

6

5/ Final colour image.

6/ A black-and-white version was also produced.

'Always make a
printout to find
subtle mistakes.'

! Feathering blurs edges by
altering the transition between
the boundary of the selection and
its surrounding pixels. This
blurring can cause some loss of
detail at the edge of the selection
where the two sides of pixels meet
at the boundary. Feathering can
be set when using the Marquee,
Lasso, Polygonal Lasso, or
Magnetic Lasso tool.

subtle adjustments

After the physical effort
to create the initial
image, it is often the
small touches post-
capture that seal the
desired creative effects.

shoot

This image, 'Lighthouse', was
shot by John Lund using small-
format (35mm) and medium-
format film. The sky and ocean
were created on the latter.
Originally, the picture of the
lighthouse was taken as part of
an advertising campaign for a
bank. It was lit with strobe lighting
at dusk. The light from the
lighthouse itself was also a
strobe. The composite image was
later created for stock purposes.

enhance

John uses Photoshop for his post-
production work. With this image,
he first stripped out the image of
the lighthouse and dropped it over

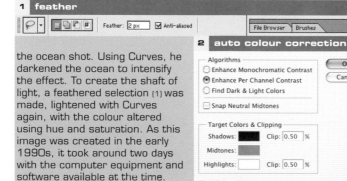

the ocean shot. Using Curves, he
darkened the ocean to intensify
the effect. To create the shaft of
light, a feathered selection (1) was
made, lightened with Curves
again, with the colour altered
using hue and saturation. As this
image was created in the early
1990s, it took around two days
with the computer equipment and
software available at the time.

enjoy

This is one of John's stock images
and has been sold through Getty
Images picture agency.

> 35mm film

> medium-format film

> scan

> Photoshop

> cut/paste

> curves

> feathering

> curves

> hue/saturation

> stock

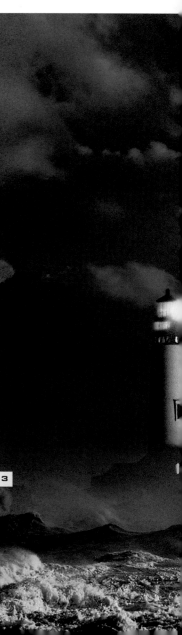

1/ Feathering a selection.

2/ Auto colour correction options.

3/ The final image.

Auto Correction It is tempting, for convenience, to utilise automatic adjustment settings, like Auto Levels in Photoshop. This adjusts the colours and contrast in an image to predefined parameters. Sometimes these do a good job (2), adjusting with a single mouse-click highlight and shadow pixels, and readjusting mid tonal values accordingly. It works best with an image having a range of average brightness values. It can also correct a colour cast. However, for your type of work it may not deliver automatic enhancement and may even introduce a colour cast. All is not lost, however. You can still use this simple step, but make it more effective by setting your own parameters. If you go into Levels or Curves and select Options, you can input values to suit your own subject matter. This option is particularly useful to the studio photographer who shoots under controlled conditions, and can help with workflow when dealing with lots of images.

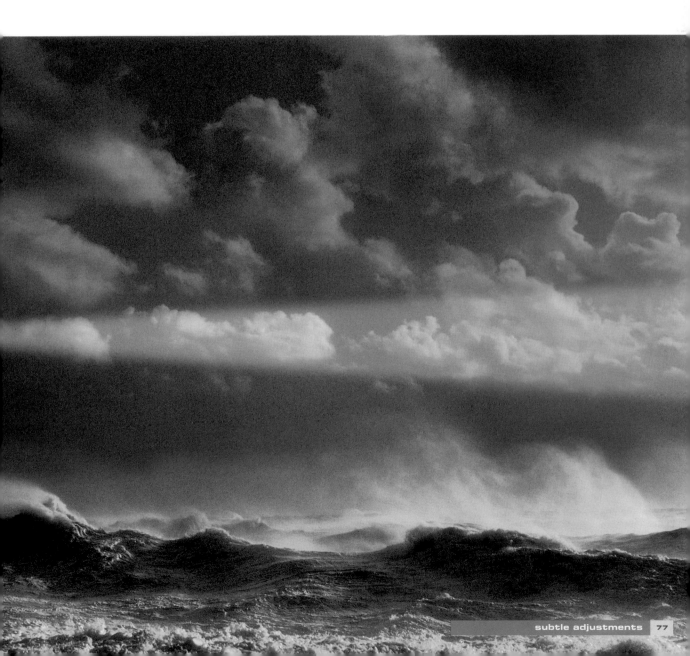

building an image

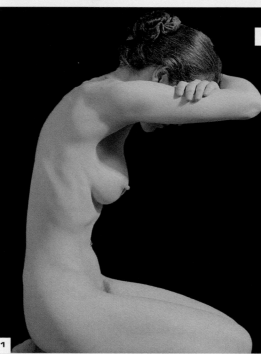

Catherine McIntyre is a widely published and commissioned digital artist. Her image 'Parchment' is an excellent example of successful modern imaging. With all the possibilities that are at our fingertips, it still takes an imaginative approach to end up with something worthwhile. Catherine finds that often an element of a captured image triggers thoughts as to how it can be further manipulated, although she sometimes shoots with a specific idea in mind.

> 6 x 6cm film capture
> scan
> flat copy
> scan
> 400dpi TIFF file
> digital capture
> Photoshop
> layers
> layer modes
> layer mask
> invert image
> flatten image
> flip image
> rotate image

shoot

Catherine used to shoot both film and digital, but she now works exclusively with a digital compact camera. Nevertheless, she finds that image quality is not an issue for the size of image produced. The nude image here was shot on a 6 x 6cm camera fitted with a standard 80mm lens. However, as Catherine explains, 'Obviously, the 6 x 6 nudes were very much sharper, but that's not always a good thing, and I almost never used them at full resolution, or they jumped.'

1/ 2/ The original images.

3/ This is the framework that stacks layers in the order you choose. Clicking on a layer makes it active, while you can make it invisible or visible by clicking the eye symbol on or off. To get rid of a layer, make it active and then drag it to the waste bin icon. Change positions by dragging the chosen layer to where you want it to be in the stack.

enhance

This image began with the basic nude shot (1), to which the photographer wanted to give a manuscript feel. The colours and composition were not pre-planned, but evolved during the working process. The manuscript document (2) was scanned on a flatbed scanner as a 400dpi TIFF file, then saved. Then the nude, letter and stamp details were added using Layers and various layer modes, including Soft Light and Overlay (both of which are popular options), combined with varying opacities (3). Layer Masks were used to remove parts of the image that were not needed. The nude was inverted, flipped, rotated and a Luminosity mode applied. The image was then flattened (Layer > Flatten Image) to remove the different layers, and make the file size more manageable. Finally, Catherine did some cloning to clean up the image. In total, a couple of hours were spent working on this image in computer.

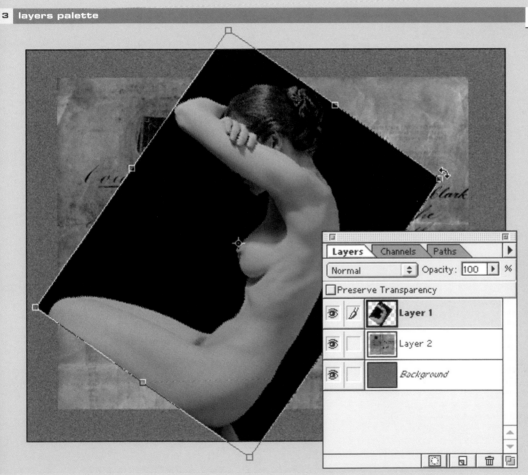

3 layers palette

! A background layer is a blank canvas onto which other component layers are placed. In Photoshop, use File > New. Set your parameters such as size, resolution and colour mode. A background layer can be made into an ordinary layer by renaming it after double-clicking its position in the Layer palette.

A layer interacts with other layers stacked below it by using layer modes. Catherine starts with a file of the planned final size, usually at a resolution of 400dpi. Often this is an abstract texture, used as a background on which to build. Then, other files are copied and pasted into the working file, but on separate layers. This early stage often requires some rough scaling and orientation of the components. Elements are blended into each other to create a cohesive result.

'To me, dressed figures are instantly located in time and define the wearer in lots of other ways too. So many messages are conveyed by clothes that aren't necessarily the ones I want to give out. Besides, I like bodies – they are great pieces of engineering!'

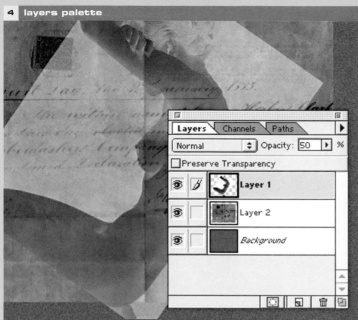

'I sit at the monitor every day and make myself produce something, but it's only sometimes that it develops an impetus of its own and becomes more than its constituent parts. The gestalt is not easily controlled. It's a matter of luck when all the things in your head – the feelings, the bits of information, the visual collection, and the actual collisions that happen on screen – combine to make something interesting.'

layers: a fundamental approach

Layers in Photoshop, or their equivalent in other photo-editing programs, are a feature that it pays to learn. When you have mastered this technique, you will advance your work on from the basic level, and layers will become a major weapon in your arsenal. The principle of layers is straightforward: component parts of an image, or the full image, can be placed separately one on top of another and arranged in any order. Adjustments can then be made to each layer. The order of the layers can be changed whenever needed as your ideas develop. Each layer remains separate from all the others until you merge or flatten them. As Catherine McIntyre describes, elements can be trimmed and rotated, just as with a paper montage. As each element is placed on its own layer, there is plenty of scope to adjust scale, perspective, distort or make other adjustments. Catherine likes to adjust opacity, often varying this across an entire layer for specific parts only. Imagination or technical need can be your driving force. Layers can be hidden, in case you want to return to them but are not working on them at that time. This can make the Layer information less confusing. You can also link layers so, for example, their component parts can be moved together into a new part of the overall composition, rather than doing this one at a time.

enjoy

This image is part of an ongoing personal project using different media.

4/ Mastering the use of layers is a valuable way of progressing your creative post-production work.

5/ The final image.

5 paper and printing

'Woods' by René Asmussen

in this chapter...

In this chapter, we look
at the various options
available to the digital
image-maker when it
comes to outputting the
final image for maximum
impact.

the paper image

Digital images need not just be
outputted as prints – other paper-
based options, such as greetings
cards, are also available.

pages 86–87

panoramic prints

Panoramic prints can be visually stunning, particularly for dynamic landscape shots, and image-editing software now makes them relatively easy to produce.

pages 88–93

print options

In this section, we examine the various print options that are open to us, including ink jet, dye sub and giclee prints.

pages 94–97

exhibition performance

Here we look at how different types of paper can be used to enhance the final print.

pages 98–99

! A sub-standard original image may leave you more creative space, as there is less to lose and more to gain by experimentation.

the paper image

Ways to use images are constantly progressing. There are some very exciting technologies being developed that may make it possible to place them on virtually any product that we may not at present associate with our image-making. However, the traditional output will probably stand the test of time, and we are not only talking about hard copy as prints. There is a massive commercial market for greetings cards, calendars, bookmarks and other paper-based products. Many can now be made with relative ease on your computer.

> 35mm film capture
> drum scan
> **Photoshop**
> crop
> duplicate layer
> eraser
> new layer
> gradient fill
> dry brush
> noise
> crop

shoot

Bruce Aiken is a designer most of the time – in fact, he's the designer of this book, along with other AVA titles. He is based in Devon, in the United Kingdom, and is also an accomplished photographer. This image (1) was originally taken for the purpose of advertising for a holiday park and stock using 35mm film.

2 eraser

enhance

To ensure high-quality scans, Bruce has used a drum scanner at his bureau for many years. This image was scanned and turned into a 12MB file. After taking the image into Photoshop, Bruce sought to reduce the resolution to help create a watercolour-style effect. Various filters were used on the image to create the final effect. The picture was also cropped substantially, with the dull strip of sand in the

foreground being removed with the Eraser (2). Bruce also wanted to create a high-key effect in the scene, to evoke the feeling of a bright, sunlit day. Levels was used to achieve that effect. A duplicate layer was created, then two others and a blue gradient fill (3) was added to one. This was darker at the base to help balance the image visually. The Dry Brush filter (4) was applied to one (Filter > Artistic > Dry Brush). The opacity of the layer was set to

3 gradient fill

1/ A rather unpromising original image.

2/ The Eraser used to take out the dark sand.

3/ A Gradient Fill on a separate layer was used to integrate the overall colour.

4/ A combination of Dry Brush and Paint Daubs was used to create a watercolour effect.

5/ The original sky was removed to reveal the Gradient Fill for a brighter effect.

6/ The final image was used on a greetings card.

70% to soften the effect of otherwise harsh edges. The sky was then selected with the Magic Wand and adjusted for colour with a Gradient Fill applied (5). To add some reality back to this smooth tone, a touch of noise was reintroduced (Filter > Noise > Add Noise). The image was finally sized at 210mm x 105mm ready for litho printing onto 250gsm card.

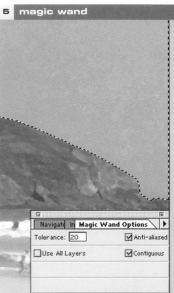

5 magic wand

6

Navigato | In | **Magic Wand Options** | ▶

Tolerance: 20 ☑ Anti-aliased

☐ Use All Layers ☑ Contiguous

4 dry brush

OK

Cancel

⊞ 50% ⊟

Options

Brush Size 10

Brush Detail 10

Texture 1

enjoy

This image has sold well as a greetings card and also as part of a special limited edition of six. People have also requested prints, so ink jet images are sold from Bruce's website.

panoramic prints

A picture's shape fundamentally changes the way a photographer works and, ultimately, affects the viewer's response. Panoramic images, with their longer than standard-sized ratio, are particularly popular with landscape photographers, but they suit other subjects too.

> long exposure

> TIFF file

> Photoshop

> auto levels

> duplicate layer

> measure tool

> spherize filter

> flatten layer

> canvas size

> select all

> opacity scale

> opacity

> mask

> gradient tool

> clone tool

> mask

> layers

> unsharp mask

> crop

> print

shoot

Yann Keesing used a 5Mp compact digital camera as the basis for what became this wonderful panoramic shot of New York, where Yann has been living for the past few years. Three exposures (1/2/3) were shot with the camera tripod mounted and set for self-timer operation. A wide-angle attachment lens (x0.7) was added to the front of the standard zoom to enable more coverage. Shutter priority exposure mode was chosen, and set to 5 seconds to record motion in the clouds. However, there was about a 30-second delay between each of the exposures as Yann chose to use the camera's noise reduction system. While this created its own problems as the clouds were moving relatively fast, it was preferable to an image where noise destroyed detail and introduced colour artefacts.

enhance

Yann used Photoshop to manipulate this image, as that is the program he is most comfortable with. First, each image had Auto Levels (Image > Adjustment > Auto Levels) applied to correct basic contrast, brightness and colour (4/5/6). The lens distortion was also corrected on each using a new duplicated layer (Image > Layer > Duplicate Layer). The images were then flattened.

Next, the canvas size of the left-hand image was increased to give roughly 10mm working room on the left, bottom and top, plus twice the width on the right side, over which the centre image was to be fitted. The image at this stage was saved as 'panorama'.

Then the centre image was selected using Select > All, and copied and pasted in 'panorama' but on a new layer named

1/ 2/ 3/ Original images.

4/ 5/ 6/ Auto Levels made basic but noticeable adjustments.

7/ Canvas size adjustment box.

8/ Spherize filter.

! *Adjusting canvas size* Either increasing or decreasing canvas size is a useful technique. In Photoshop, canvas size is set using the Image > Canvas Size menus. A dialog box appears [7] into which you can type the desired value for change in either percent, pixels, inches, mm, cm, points, picas or columns. (If you want to reduce the canvas size, type in a minus value.) The added area will appear in the colour of your current background colour. Click OK and the change will appear. You can also move the anchor point of the original image on the new canvas by clicking in the grid, so any adjustment takes place from that new position rather than a central one.

! *Distortion correction in Photoshop* Yann used the following method to eliminate distortion. First the canvas size was changed so it became a square, leaving room all around the edges of the image. For example, if your image is 4 x 6 inches, try creating a canvas size of 7 x 7 inches. This is important for what comes later. Yann prefers white as his background colour, but with some images another colour may be easier to work with. Using the Measure tool, make sure that the furthest points of your horizon (left to right) are level and adjust by rotating the canvas (Image Rotate Canvas > Arbitrary) by the amount indicated. If needed, use the Spherize filter (Filter > Distort > Spherize) [8] with a small 5 or 10 value set to counteract to make the effect look more natural. If you have some buildings or other straight-line objects at the top of your horizon, you might want to play with the perspective using Perspective Crop adjustment. Now crop your image to lose any unwanted canvas.

7 canvas size

Current Size: 1.28M

Width: 4 cm
Height: 6 cm

New Size: 2.61M

Width: 7 cm ▼
Height: 7 cm ▼

Anchor:

8 spherize

100%

Amount -5 %

Mode Normal ▼

5 6

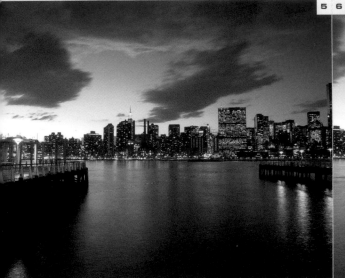

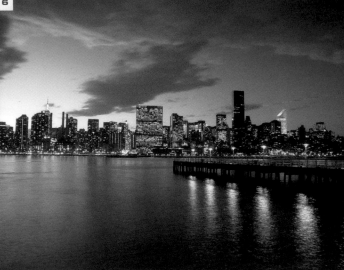

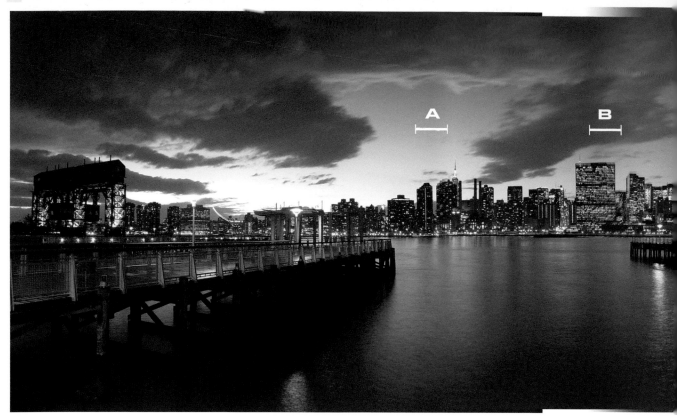

9/ The three images were combined in one document but on three different layers.

10/ The Layers palette showing the management of the three images.

11/ Correcting the sloping horizon with the Measurement tool.

'centre'. It was important that this image was on top. A neat touch was to then create a ruler with the Measurement tool (see box opposite) running along the horizon to make sure that it was straight all the way across. Yann then lowered the opacity of the centre image layer downwards, so he was able to see through it to the image on the left. When all looked right, it was aligned with the left image precisely, but needed a very small amount of scaling up in size. This is common when stitching different shots together, as some borders are recorded smaller than others as the

camera lens is adjusted for each image. The opacity was then set back to 100%.

So far so good, but now for the precise stitching of the images to make things look natural and seamless. Initially, an area where the stitching wouldn't look too obtrusive was found around the two highest buildings in front and left of the Empire State Building. A mask was placed over the centre layer and the Linear Gradient tool set as 'foreground to background' with the foreground colour white and the background colour black. A gradient over the mask from right to left was created with

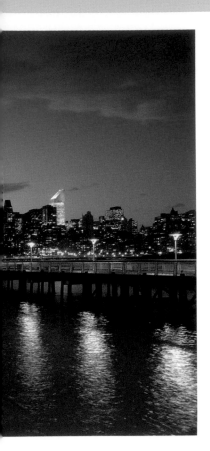

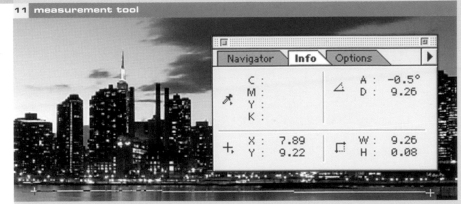

! **Measuring the horizon** A sloping or curved horizon seem instinctively unnatural. The Measurement tool is useful in Photoshop to correct this. You select the Measurement tool from the Tools menu and click on where you wish to start the measurement. Move the line to your end position and release the mouse. The info panel will show if the line is slanted and by how much.

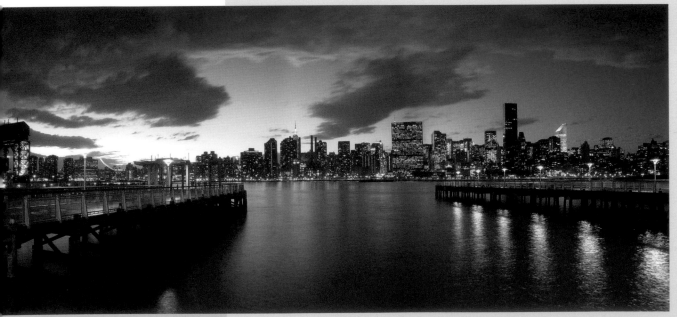

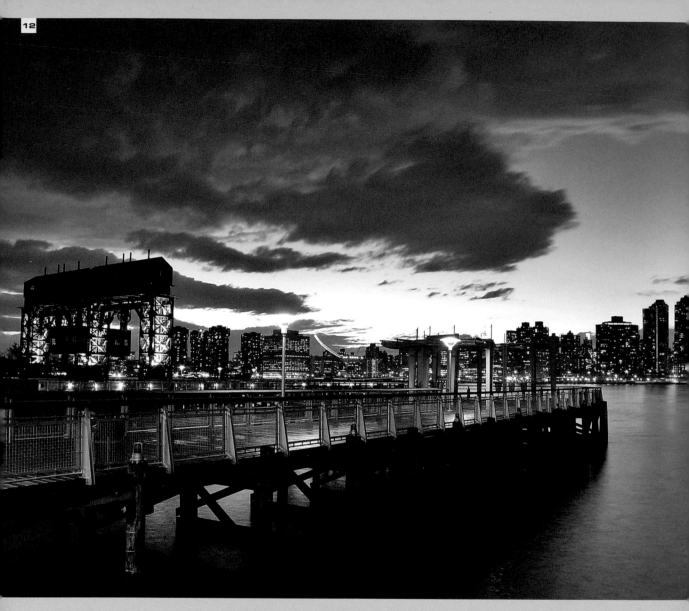

12/ The final image.

concentration so that the gradient line was perfectly horizontal. This was made easier by zooming into the image. The origin point of the gradient was just above the red and green building (the Empire State), ending about 10mm to the left. The image was then saved. The right-hand image was created in the same way and joined to the centre part of the panorama. Yann then started to work on specifics, deleting parts while cloning some areas, and using masks to enhance what he wanted. He also adjusted levels on individual layers. The image was then flattened, levels adjusted once more to get better reproduction of the city's lighting, and a slight Unsharp Mask filter applied. A crop for the best composition and to get rid of the white background ended the process.

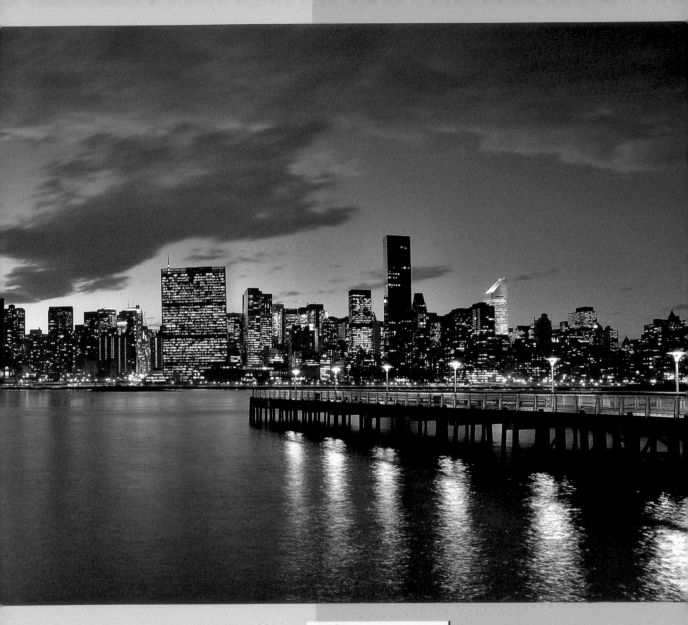

enjoy

The final image size is 368mm x 145mm at 300dpi. Yann uses this image on his website but has also output it using a desktop ink jet printer and its paper roll facility. This enables the exact and desired length of print to be output.

Many of us feel that an image is finished when it is output onto paper, and perhaps framed and hung on display. The time and effort put into the image up until this point surely deserves this final accolade. Photographers who sell their work continue to do so in the form of 'hard copy' as well as producing images to be sent over the internet. What materials are best for producing prints? Well, size of print, speed of production, costs and quality all differ across an increasing range of options. Here we consider the popular options of ink jet, dye sub and silver halide.

print options

© Suffield Panoramas

1
2

1/ 'Golden Sunrise' by Wayne Suffield is a panoramic image that was created from three film originals. Each was scanned at 2700dpi, resulting in files of around 27MB. These were adjusted within Coral Photopaint software using the Curves function. Panavue's Image Assembler software was used to stitch the three images together. Brightness and contrast adjustments were made to overcome slight exposure differences between the images. The image was then resampled at 300dpi ready for printing. This image has sold at various sizes from a 5-inch print used as a bookmark to a print 40 inches wide. That image was framed, after being block-mounted and laminated for maximum impact.

2/ Dye Sublimation (Dye Sub) printers used to be relatively expensive, large and heavy products. These issues are increasingly being overcome. The photorealistic finish achieved by this method is a big appeal.

silver halide

Having images output onto photographic paper remains an appealing option, and it is becoming easier and cheaper as time goes by. Colour reproduction and print longevity are trusted by photographers and buyers of the work, so there seems little reason not to let your lab print your digital images in the traditional way. This process can be especially useful for large print sizes and when a large number of prints are needed quickly. Digital files are converted from an RGB colour space into the CMYK option needed for printing.

! Whatever technology you employ, use a printer that allows a 'full bleed' of the image to the edges of the paper. You may not always want this, but this option should be available to you if you do.

dye sublimation

Dye sublimation printing has an increasing number of devotees. Desktop units have come down in price rapidly and reduced in size. With output speeds increasing, this is also now a practical solution for many home and professional studios, or for photographers covering events on location. Dye sub prints tend to be more fade-resistant than many ink jet materials. Another big attraction of this method is the photorealistic look that it produces through its continuous tone reproduction. This is achieved using a ribbon of dyes (one each for cyan, magenta, yellow and black), each heated and passed across the paper one at a time. When heated, the dye vaporises, sinks into the receptor paper and solidifies as it cools. A final protective layer is applied. This can be written on, and provides humidity protection. Paper and dye are purchased together in a sealed pack.

ink jet

Ink jet printing has been a major instigator in creating the 'digital revolution' in photography. It has a price performance that attracts many, from the enthusiast to the professional. Materials have come a long way, and we can now choose from a wide range of papers and inks. However, the principle of an ink jet (also called bubble jet) printer means that not all things are equal and you should test printer, paper and ink combinations to find the ones that work best for you. For instance, ink is heated and squirted onto the paper's surface as differing dot sizes. If the paper does not have the right absorption properties for the ink used, it may spread too much or too little. This will affect the colour reproduction. Swellable papers will also take a little time to dry compared to the instant drying of conventional types.

One of the benefits of ink jet printing is the fact that there are so many paper types around; you can make the same image look quite different just by changing the output material. It is doubtful that the digital worker can equal the choice and creativity of ink jet printing with other methods of printing.

The downside of ink jet printing probably remains the time factor, so it is wise to look at alternatives when you need a large number of prints. The final aspect to consider is the ink technology. This is often based on dyes, but pigment inks are also popular. The first has a better colour gamut that is nearer to a conventional photograph on silver halide paper. However, it has a shorter life expectancy before it will fade and it may need special storage and viewing to reach the manufacturer's quoted life span. These are, therefore, good options for 'proof' prints. Pigment dyes have a longer life-span, but are still susceptible to improper storage (see Giclee). They also tend to have a reduced colour range.

giclee

Giclee is something to consider if you are looking for archival print quality from an ink jet method. Giclee uses a continuous tone ink jet that has archival qualities. This long-term stability makes giclee prints suitable for sale as 'fine art' prints. Be warned that giclee is an expensive process that is carried out by only a small number of companies.

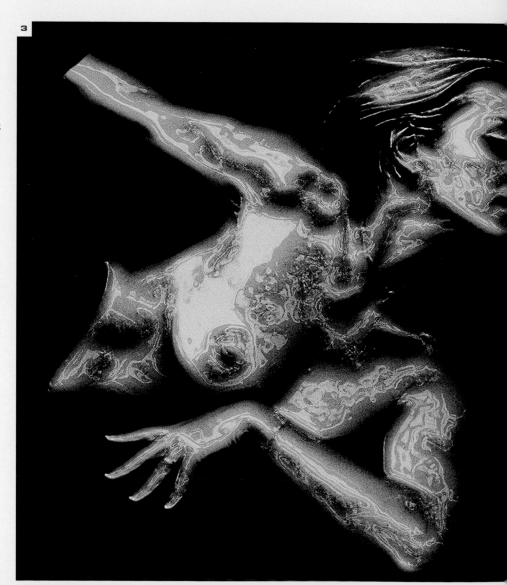

3

4 print control panel

Color Density

⬛ `0` (%)

-50 +20

Drying Time per Print Page

⬛ `1` (sec)

0 +20

[?] [Default] [Cancel] [OK]

❗ An ink jet offering a sheet-fed paper roll is useful for panoramic print output.

3/ This image by John Peristiany was created with numerous stages, including application of a plug-in filter. Its special character may call for a less than conventional paper to give it greatest impact. Give every thought to this aspect of your workflow.

4/ 5/ Advanced software tools allow mastery over print output quality.

❗ *Metamerism* This is an effect to be aware of, particularly if you are selling your work. Ink colour can look different under varying light sources and can change the overall colour balance when viewed under, say, daylight and then tungsten illumination. It is best to examine images in the lighting under which the print will normally be viewed.

5 print control panel

Media Type: [Archival Matte P... ▾]

Color
- ⦿ Color
- ○ Black

Print Quality: [Photo - 1440dpi ▾]

☑ MicroWeave
☑ High Speed
☐ Flip Horizontal
☑ Finest Detail
☑ Edge Smoothing

Color Management
- ⦿ Color Controls Gamma [1.8 ▾]
- ○ PhotoEnhance4
- ○ ColorSync
- ○ No Color Adjustment

Mode: [Photo-realistic ▾]

Brightness	`4`	
Contrast	`5`	
Saturation	`1`	
○ Cyan	`1`	
● Magenta	`-3`	
○ Yellow	`1`	

[?] [Paper Config....] [Save Settings...] [Cancel] [OK]

❗ Weight of paper is important if you want to produce photorealistic prints. Try using ink jet materials of at least 260gsm.

enhance

Whatever method of printing you use, you should give the printer the best file to work with. Some printers intended for home use are better off with JPEG files. Larger TIFF files slow down printer speed by hogging space in the buffer memory (the RAM allocated to store image data prior to printing). Many ink jet images output on such printers to moderate sizes can be printed to around 150dpi and still yield a photographic quality. However, the general guide for printing with ink jet and most dye sub machines is 300dpi. There is a case with some products for setting a higher value, such as 400dpi, but this is redundant quality on most machines unless indicated.

enjoy

Framing an image is a good way of adding a finishing touch to your work. Choosing the right frame style and colour remains a crucial role for the photographer. Likewise, a suitable mount can make or break an image. Lamination is also worth considering to protect a print from humidity and direct impact.

'I make pictures, I don't take them...'

1

2

exhibition performance

in, to prevent it looking too artificial. Cloning over parts again can also add some reality by breaking up the pattern. A touch of noise was also introduced (4). This gives digitally captured shots more of a film-like quality. Once again, colours were adjusted. The horse was then placed, with its

While it is generally best to conceive the optimum workflow based on the final use of an image, sometimes that will change over time. However, this does not mean you cannot adapt an image, as we have here. Sometimes, for example, we need to change an image originated for the web into one for print output.

shoot

Tom Bjornland is based in Moss, Norway. He creates images primarily for display in galleries and in people's homes, as well as for stock. Most of his work is shot on a professional 35mm-style digital SLR, but this image, 'Mustang', was captured on a low-resolution 2Mp camera. Digital capture to Tom is a small, although crucial, aspect of his workflow. He estimates that 80% of his creativity takes place at his computer. He thinks of digital capture as being simply a means to collect the raw material needed for his creative work. With regards to this image, the shots of both the horse and the background were taken along a route that Tom regularly walks on and which is part of a friend's farm.

enhance

The image was created when Tom was playing around within Photoshop trying things out. It consists of two original files, the horse and the background (1). The original of the horse has unfortunately been lost, but was created for web use initially, and was probably only 400–500Kb as a consequence. The final image seen here is small, about 10 by 5cm at 300dpi, but we interpolated it for this book by 250%.

The original JPEG image was cropped slightly and a larger sky area added after changing the canvas size (2). The sky was added as a separate layer, with adjustment made to the hue and saturation. A further canvas size adjustment was made to enlarge the image horizontally (3). Cloning was used to extend the width. The Eraser tool can be used to take away parts of the image cloned

> **Photoshop**
> canvas size
> hue/saturation
> canvas size
> clone tool
> noise
> **PSD file**
> colour adjustment

3

1/ The original shot of the background.
2/ Expanding the sky area.
3/ Extending the image horizontally.
4/ Adding noise.
5/ The final image.

opacity adjusted on a separate layer to make it look more natural. Further colour adjustments were made (5). At this stage, the image was saved as a PSD file. In total, around two hours were spent working on the image.

! Play, and try to experiment. Never be afraid to try out an idea of your own.

enjoy

Tom usually makes prints on canvas up to one and a half meters long. This is a job for a professional print company, although canvas-like materials can be used in many desktop ink jet machines for smaller sizes. He also finds watercolour paper suits his type of imagery, especially for sale in exhibitions. Some of his other work is also used for advertising and in magazines.

5

4

! The wide range of paper materials available today is a major advantage to the digital worker. The same image printed on different papers looks very different, so it is worth experimenting and having a range of types to hand. For instance, parchment and other 'art' types can add that extra touch, although not every image will be suited to such finishes. If it is something more traditional, then there are plenty of options, from gloss to high gloss, through matt and lustre finishes.

6 monochrome magic

'Wakey Wakey' by Royston Matthews

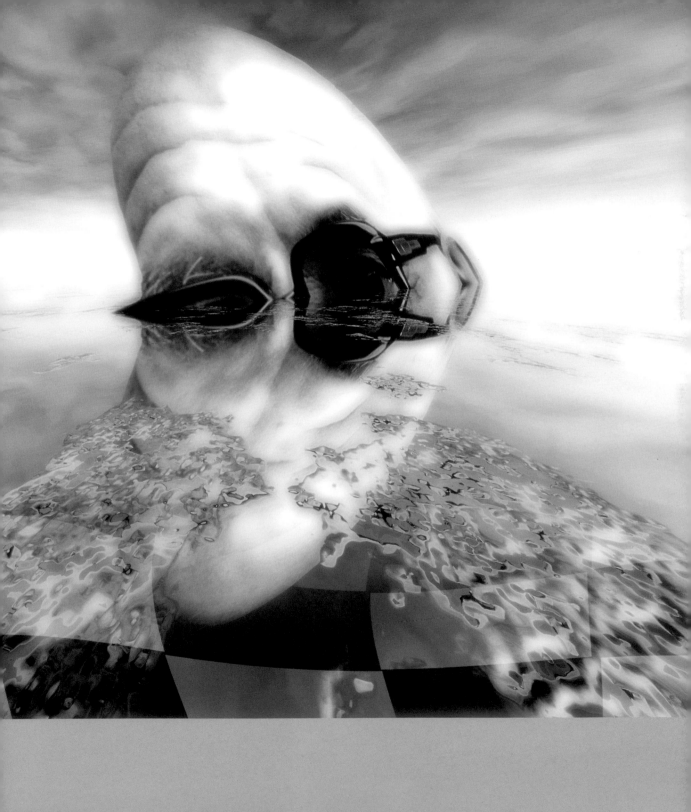

in this chapter...

Monochrome imagery is
always popular in
photography, and digital
imaging expands our
creative options for
making atmospheric
black-and-white pictures.

sepia toning

Sepia toning is a very popular effect
used to enhance monochrome
images. Here we examine a number
of techniques for creating it.

pages 104–107

digital infrared

In this section we look at using
digital tools to create the distinctive,
otherworldly effects of infrared
imagery.

pages 108–109

creating monochrome

There are a number of ways of creating monochrome images, including turning the picture into a greyscale; using the Hue and Saturation sliders; or using the Channel Mixer.

pages 110–111

ink jet monochrome

Ink jet printing equipment is now reasonably priced and can produce stunning monochrome results.

pages 112–113

1

sepia toning

2

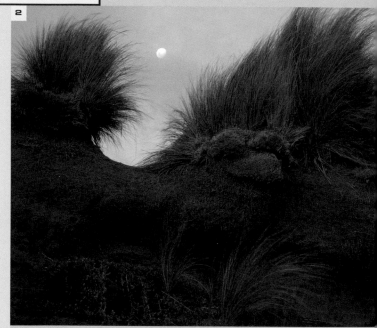

Sepia toning is a wonderfully atmospheric, nostalgic effect, which is relatively easy to create digitally – a far cry from the days of toning film prints with chemicals!

shoot

Juergen Kollmorgen is originally from Germany but now lives in China. He specialises in fine art photography. This is a tough area in which to succeed, but one where digital imaging increasingly has a role to play. Juergen works largely with film capture, but he sees traditional and modern imaging as a means to an end, so he also uses digital cameras.

This image, called 'Moonrise', started life as a digitally captured shot on a high-quality 5Mp compact digital. It was taken in Australia, at the coast near Melbourne. Juergen was heading to his car after taking some shots of sunset scenes when the possibilities of this shot presented themselves. It was a moment, already after sunset, when the moon appeared for a short time from behind cloud, and patches of grass on the cliff were illuminated from behind by it. As the camera was on a tripod, it was possible to stop the lens down to the minimum f/8 aperture and utilise a one-second exposure.

> TIFF file
> Photoshop
> desaturate
> levels
> curves
> dodge & burn
> new layer
> gradient map
> duplicate layer
> hue/saturation
> flatten
> ink jet
> web

enhance

Juergen spent around an hour working on this image. Owing to the low light, the original colour image lacked contrast and was rather flat (1). The first step was to desaturate the RGB image via Image > Adjustments > Desaturate (2). Next, the tonal range was modified. For this, Juergen likes to use the histogram information in Photoshop. To judge how and

where the pixels were arranged, Image > Adjustments > Levels were displayed. This showed that there were no true highlight details recorded, the brightest being at a pixel value of 203 (out of a maximum of 255). Using the adjustment slider on the right below the histogram, Juergen forced those pixels to record as brighter than they were originally (3). Then Curves

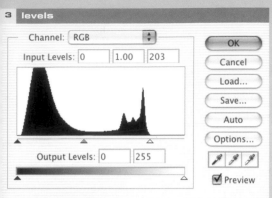

3 levels

Channel: RGB

Input Levels: 0 | 1.00 | 203

OK
Cancel
Load...
Save...
Auto
Options...

Output Levels: 0 | 255

☑ Preview

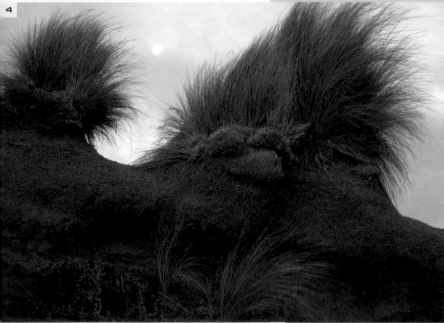

4

1/ The original image was lacking in tonal contrast.

2/ The image was desaturated to turn it monochrome.

3/ The tonal range was adjusted using a histogram.

4/ Curves was used to boost the image's contrast further.

5/ The Curves settings that were used.

An alternative route
There are numerous ways to create a sepia or other tonal effect. If you want to try something quick, use Image > Adjustments > Desaturate to take away the visible colour of the RGB image. Then, with Image > Adjustments > Colour Balance, set yellow at -100% and reduce red to your taste. That will give a pseudo-sepia look – not the same as 'Moonrise' but something to catch the eye. Further quick refinements can be made by using the variations display (Image > Adjustments > Variations) and selecting or modifying the image from there. Alternatively, reduce yellow and magenta, but not to maximum, then increase the red content.

(Image Adjustment > Curves) were manipulated to increase contrast without losing detail in the clouds (4/5).

Next came the modern equivalent of the print-makers' art: dodging and burning to decrease and increase the brightness of specific parts of the image. The Dodge tool was used first to brighten the highlight areas of the grass,

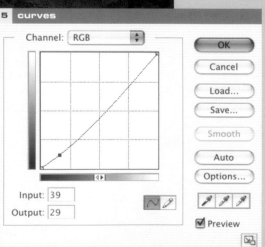

5 curves

Channel: RGB

OK
Cancel
Load...
Save...
Smooth
Auto
Options...

Input: 39
Output: 29

☑ Preview

7 **gradient editor**

Presets

Name: Foreground to Background

Gradient Type: Solid

Smoothness: 100 %

Stops

Opacity: % Location: % Delete

Color: Location: % Delete

OK
Cancel
Load...
Save...
New

6/ Dodging and burning enhanced the image further.

7/ The Gradient Editor was used to create the atmospheric sepia tone.

8/ The final image.

8

while the Burn tool darkened the shadows (6). Using a new layer (Layer > New Adjustment Layer), it was then time to create the sepia effect using a gradient map. In the dialog boxes that appeared, Multiply, rather than Normal, was selected from the drop-down menu, and Opacity was reduced to 74%. After confirmation that this was wanted, double-clicking the mouse into the gradient box

6

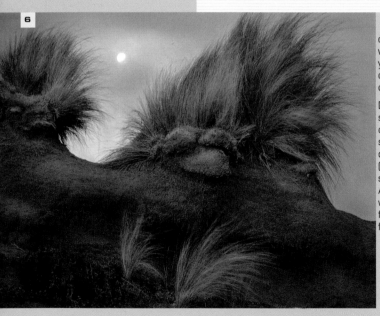

opened the Gradient Editor (7), where shades of brown and yellow were selected, giving the overlaying gradient map the desired sepia tones.

Dither and Reverse were also selected to change both the direction of the gradient and to soften the transitions. A duplicate layer was created (Layer > Duplicate Layer) and some fine-tuning using Image > Adjustments > Hue/Saturation were made to adjust the colours further (8). The image was then flattened.

The ability to make his own prints is essential to Juergen. He uses an ink jet printer with pigmented rather than dye-based inks and chooses a paper, usually a watercolour paper, to complement the image. Some prints are produced purely for his personal enjoyment, but some are made for galleries and exhibitions. However, Juergen realises that art photography is not destined for the largest possible audience, but for a more discerning one.

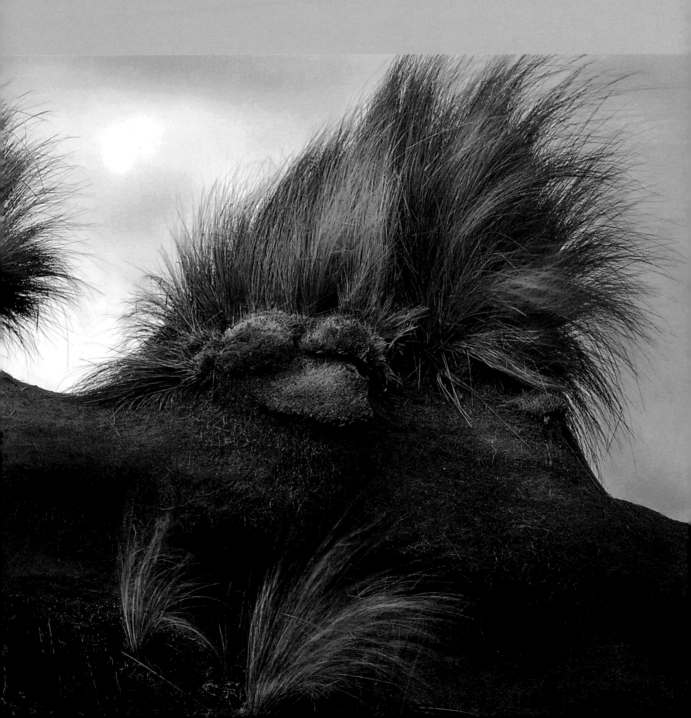

1

> **!** Not all cameras are suitable for infrared photography. A guide to your model's suitability is to take a television remote control into a dark room and set your camera for a long exposure. Take a shot and see if you get a response when the beam is projected. This will show if there is a usable infrared sensitivity.

digital infrared

This shot demonstrates the characteristic strength of infrared photography: its combination of realism and surrealism.

shoot

Out of the camera, this shot by Felipe Rodriguez had the typical reddish tones created by light passing through the infrared (IR) transmitting filter that had been fitted onto Felipe's 5mp SLR camera [1]. He used a 100 ISO rating, which gave an exposure of 1/2 sec at f/6 and provided a useful, although not a vast, depth of field and a shutter speed that kept the noise created by a long exposure time down to a minimum. The captured image dimensions were 1920 x 2560 pixels, and the resulting file was 18.7MB.

enhance

The picture was adjusted to correct sloping, via the Crop tool and its perspective control in Photoshop. A rubbish bin was also cloned out of the shot. The image was then converted to greyscale, using the channel mixer (Image > Adjustments > Channel Mixer) [2]. Felipe used only the red and green channels to avoid the excessive noise contained within the blue channel that is common in many infrared shots. Then Levels (Image > Adjustments > Levels) were adjusted to gain more contrast and extend the tonal range [3/4/5]. The shot was subsequently put through NeatImage software, and noise was reduced further. Felipe has found this program to be very effective when applied to smaller pictures. Sharpening was also applied at this stage. Finally, a solid colour layer in the colour fusion mode was applied to tone the picture and give it its sepia-like effect.

2 channel mixer

3 tonal adjustment

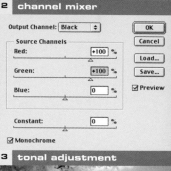

4 levels (before)

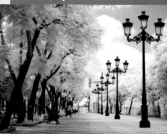

5 levels (after)

> infrared filter
> Photoshop
> crop
> perspective crop
> clone
> channel mixer
> greyscale
> levels
> NeatImage software
> sharpening
> tone
> web

> **!** There are many filters suitable for near or purely infrared photography. Typically, you need a filter with a transmission range above 800nm (nanometres) in order to completely block other parts of the colour spectrum from reaching the camera's sensor and destroying the infrared effect. The visible spectrum, in comparison, ranges from around 400nm to 700nm.

7

enjoy

This file has been produced for a large print output (6). A smaller version for the internet was created in the NeatImage software (7). Felipe finds that different resolution makes for unmatched images using that software, and this version was more appealing on screen.

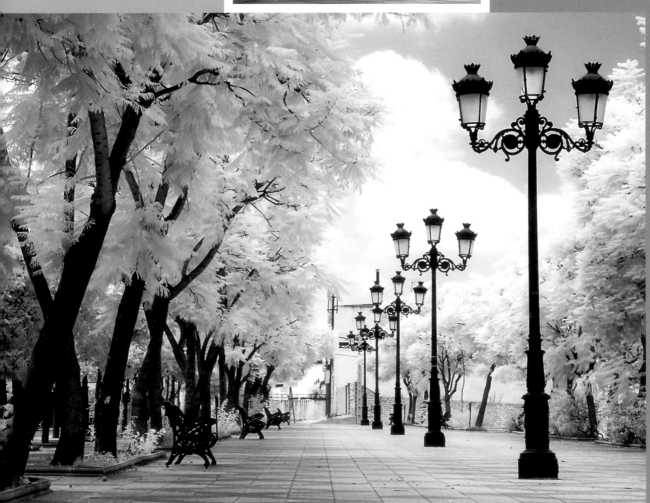

1/ The original image.

2/ Greyscale conversion using the channel mixer.

3/ 4/ 5/ Levels were adjusted subtly to add contrast and extend the tonal range.

6/ The final image.

7/ The image reduced for the web.

'Some people use adjustment layers to do just about everything. I use layer masks in the same manner. Learn what works for you and experiment from there.'

'If you are trying to make something look real, be aware of the lighting. When I work on a composite, I try to make sure all the elements have similar lighting and shadowing. Shadows and lighting can transform an amateurish cut-and-paste composite into a realistic work of art.'

creating monochrome

There are several digital routes to creating monochrome images, and this striking image shows how much impact a black-and-white picture can have in a world dominated by colour photography.

shoot

Peter Casolino is based in New Haven, Connecticut, USA. This image was captured on film, using a basic 35mm rangefinder for the landscape shot. This was fitted with a 35mm lens, giving the photographer something close to the angle of view and perspective that our eyes have. Peter is also aware of the benefits of digital capture, which he appreciates for its smooth, noise-free files, and he also shoots medium-format film.

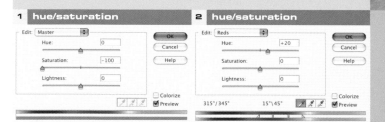

> 35mm film capture
> scan
> Photoshop
> copy
> flip
> extend canvas
> paste
> eye image
> copy
> flip
> extend
> paste
> new layer
> paste
> layer overlay
> layer mask
> paint
> monochrome
> flatten

! *Losing/adjusting colour* There are numerous ways to create a monochrome image, or even a toned monochrome shot. One common approach in Photoshop is to remove colour values and turn the image into greyscale: Image > Mode > Greyscale. This removes the colour permanently once the image is resaved. Other programs, such as Photoshop Elements, have a **Remove Colour** option (Enhance > Adjust Colour > Remove Colour)

that does the same thing. Alternatively, try Image > Adjustments > Hue/Saturation and set the latter to -100 (1). This does not removed colour permanently at this stage. If you then check the Colorize box, you can adjust the slider controls to introduce subtle or harsh colour back into the image. A different route is to select a specific colour channel before activating the Colorize option (2). One

underutilised route is to use the Channel Mixer in Photoshop or similar (Image > Adjustments > Channel Mixer) when you check the Monochrome box (3). This enables the image to be adjusted for contrast by using the sliding controls subtly. Alternatively, if you then uncheck the box and adjust the controls, colour is re-added as a tone.

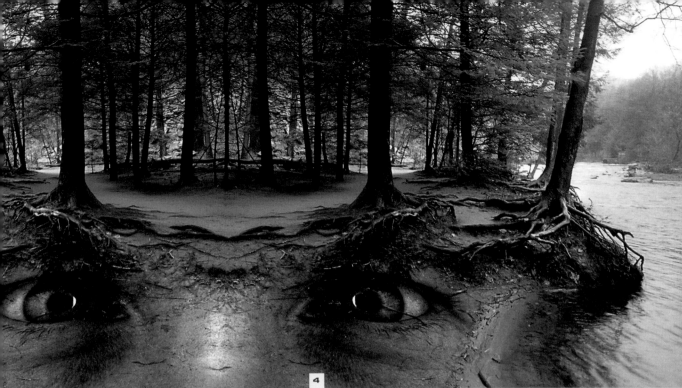

4

3 channel mixer

Output Channel: Gray

— Source Channels ——————

Red: +100 %

Green: 0 %

Blue: 0 %

Constant: 0 %

☑ Monochrome

OK
Cancel
Load...
Save...
☑ Preview

1/ Creating monochrome via Hue and Saturation.

2/ The Colorize option in Hue and Saturation.

3/ Creating monochrome via the Channel Mixer.

4/ The final image.

enhance

Photoshop was used to create and manipulate the final image. The original landscape, comprised of a river and part of its shore, was copied and flipped horizontally (Image > Rotate Canvas > Flip Canvas). This was pasted next to the original after extending the canvas size to accommodate it (Image > Canvas Size). This made the image twice its original length, resulting in a panoramic image. In the studio, Peter then shot the eye and

followed the same process to produce a horizontal shot of two eyes. These were then pasted twice over the landscape using Layers. The first was made into an overlay, and the second left as it was. Peter used layer masks on both layers to paint just enough of the eyes into the landscape for the desired effect. The image was then turned into monochrome. In all, this image took about one hour of work post-capture.

Start with an idea. You can spend hours fumbling around with image programs if you have no idea what you want to create.

enjoy

This image was made for stock and has been used to illustrate science articles on the theme of 'humanity and nature'. Peter's output is varied, ranging from

photo-illustrations for newspapers, to work for magazines and stock agencies. He also sells some of his digitally enhanced images to collectors as limited-edition prints.

! Some companies offer a calibration service based on your system. The monitor, printer and paper type are all considered. This 'closed loop' system enables predictable results from the on-screen image.

1

ink jet monochrome

Many photographers regard in-house ink jet printing as a fundamental part of their image-making. It has gained popularity, especially with those looking for high-quality mono prints.

shoot

This picture was taken by Andrew Maidanik, who is based in Toronto, Canada. It was shot using a pro-level digital SLR and a 20–35mm lens, with an exposure of 1/125 sec at f/11. The location was a lake near Toronto. Andrew likes the result because, while many different photographs of the bridge are taken, most photographers fail to see this perspective of it.

! *Ink jet output* Pro-level ink jet printers and peripherals are now available at a reasonable price. It is best, however, to avoid standard ink jet printers bought for general colour output. Even those deemed suitable for photo quality can lack sufficient ink types to produce a good tonal range. Mono prints are best created with printers using around seven separate inks, with some or all specifically developed

for black-and-white output. It is also useful to look at third-party continuous ink systems, where large-capacity ink is fed all the time into the printer. This saves time and costs with high-volume output.

2

! *Dye or pigment inks?* Ink jet printers fall into two types: those using dye-based inks and those utilising pigments. There are pros and cons with either system. If you use your ink jet more as a proof than as a final product, then dye-based systems are faster and usually cheaper to operate. The

dyes tend to dry faster too. Pigment inks, however, have a significant longevity advantage, if stored in the right way, although their gamut of colour is not as wide. Technology is developing all the time so it pays to keep up to date with the new materials available.

enhance

Andrew enhanced the image in Photoshop using a variety of plug-ins such as AutoFX and KPT. About an hour was spent working on the shot.

enjoy

Andrew makes landscape prints mostly for his own exhibitions, unless the work has been commissioned. Increasingly he is making sales to private collectors.

1/ Optimum printing results are to be had with ink jet printers offering at least seven ink types.

2/ The best monitor calibration comes from a physical measurement of its characteristics. This avoids the working environment affecting the results. A suitable 'spyder' is worth the expenditure, as this needs to be repeated often.

3/ The best mono output needs subtle grey shades as well as black-and-white tones.

> **Photoshop**
> **Plug ins**
> **TIFF**

7 surreal and conceptual images

'Red Tulip Field' by Jaap Hart

in this chapter...

Digital imaging tools really come into their own when we want to produce surreal and conceptual images – the sort of arresting, extraordinary pictures that could never have been created using conventional methods.

montage

Montages are a great way of creating eye-catching, dramatic pictures.

pages 118–121

using filters

The numerous filters that are available in photo-editing software can be used to enhance images in subtle or dramatic ways.

pages 122–123

dramatic colour

Digital tools allow the photographer to manipulate the colours in an image to create surreal, almost abstract, artistic effects.

pages 124–127

adding movement

The addition of movement to a picture can create a sense of extra drama that draws the viewer in.

pages 128–129

working with layers

Layers is an invaluable tool for working on complex images, particularly when applying different effects and filters.

pages 130–133

1

2

montage

Montages are a way of creating stunning and dramatic images that could never be created using traditional photographic techniques – at least, not without great expense and laborious set-ups!

> film capture
> scan
> **ECLIPSE**
> curves
> shapes
> colour
> paste
> Photoshop
> motion blur
> **ECLIPSE**
> shapes
> marquee tool
> colour
> shapes
> rotate
> shapes
> transparency vignctte
> copy
> paste
> distort
> transparency vignette
> smear brush
> **TIFF**
> transparency

shoot

Thomas Herbrich is based in Dusseldorf, Germany. A professional commercial photographer and accomplished digital worker, he shot medium- and large-format film until quite recently. Now he uses only digital capture, as it is quicker and no longer overly expensive. However, this shot, 'Car Exploding', was originated on 5 x 4inches large-format film, with the explosion itself captured separately on a 6 x 6cm medium-format camera. The

shot came about when Thomas was given an open brief by Chrysler to create a calendar image for their 300M car. This image is one of two that he created for the client.

The image of the car was taken on a parking lot near Thomas's studio one afternoon [1]. In the final image, it looks as if this is a night scene and that the car is jumping. The very convincing-looking explosion was in fact quite

easy to simulate using white powder against a black cardboard background. This was, as Thomas puts it 'a trick – without any danger – a child could do it'. A spoonful of washing or talcum powder is placed in the middle of a piece of black cardboard (70 x 100cm). Then a can of compressed air (the same that is used for cleaning negatives) is sprayed into the powder. This results in a kind of grey cloud on the black background [2].

enhance

Thomas uses ECLIPSE software (www.formvision.de) for 99% of his work, doing only a small amount in Photoshop. ECLIPSE is designed to work with very large files, but only on some platforms. After scanning the two shots, a basic adjustment was made to the gradation cur·ves, giving the desired contrast of the background. Then the colour of the flames was added (3). With this software, you use Shapes rather than Layers as in Photoshop, although the speed effect was added using

3 **modify correction**

! Before you start, think about storing the picture and being able to find it later. A big, removable hard disk is more useful than a box full of CD-ROMs.

5 new shape

Photoshop's Motion Blur filter. Shapes are freely editable; they are movable areas that you can fill with things such as a colour, a correction, noise or other effects, and are a common feature of that program.

Working on a selected area made with a Marquee type of tool, subtle colour adjustments were made to the flame tips, so they were not a uniform orange [4]. Next, the car was placed over the top of the first image, then rotated into the desired position [5]. A transparency vignette was added to allow the car to stand out more [6] as if

1/ The original image of the car.

2/ The 'explosion'.

3/ The 'flames' were created in ECLIPSE software.

4/ The colour of the flames was adjusted to make them look more realistic.

5/ The two images were combined and the position of the car adjusted for dramatic effect.

6/ A transparency vignette was used to make the car stand out more against the flames.

6 transparency vignette

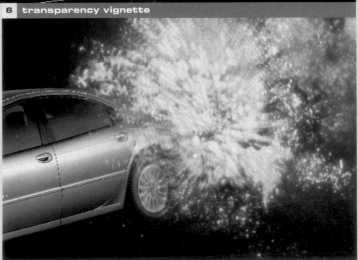

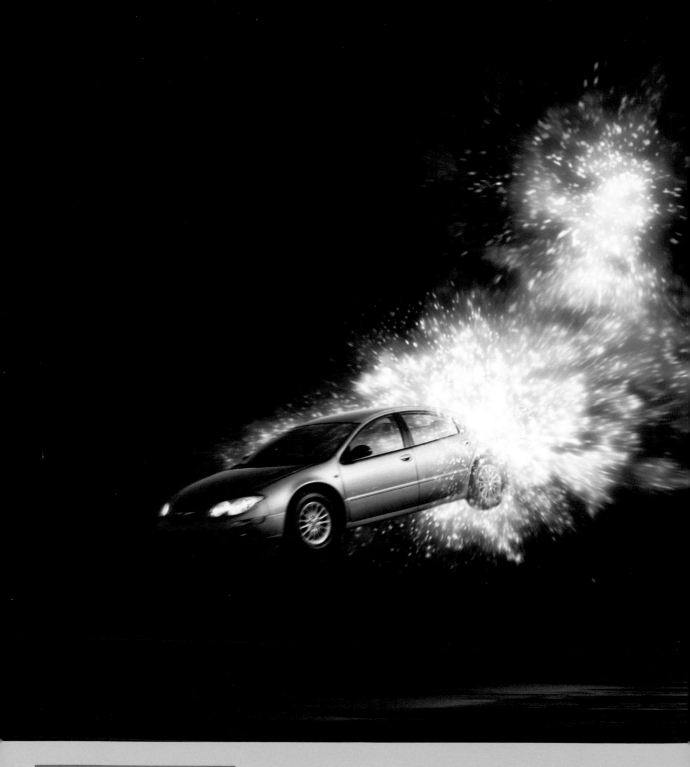

surreal and conceptual images

the flames were around it rather than inside it. To obtain the reflection under the car, flames were copied and placed into position (7); distorted using a Shape adjustment option; and then had a transparency vignette applied (8). This reduced illumination towards the edges. The final step was to use a smear brush to add a halo to the edge of the flame.

7/ A duplicate layer was used to create 'flames' under the car.

8/ Another transparency vignette was used to make the final adjustments to the flames.

9/ The final image.

7 duplicate layer

8 transparency vignette

9

Thomas does not produce prints but writes his files back out onto transparency film. Then the image is flattened and saved as a TIFF file. Specifically, he maximises their impact as 8 x 10in transparencies; he also likes this as a storage medium. In total, three days were spent in post-production.

'I work the subject, looking at it from all angles and shooting a lot in an attempt to find the ultimate image of that particular subject at that particular time.'

! Be careful not to overexpose. Detail in burnt-out highlights (pure white) can't be salvaged, although slight underexposure often can be recoverable via Photoshop layers with specific treatment to those areas.

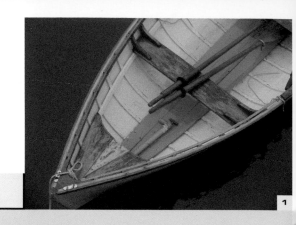

using filters

Using filters in photo-editing software is a very useful way of enhancing an image, whether you want to make a startling and dramatic effect, or create something more subtle and atmospheric.

shoot

Charlie Morey is a professional photographer based in Los Angeles. This image, 'Blue Row Boat', was taken before Charlie started using digital SLRs with a digital compact. The exposure was 1/60 sec at f/2.8. The image was created as a JPEG file during a photoshoot in Maine, to capture the autumn foliage and other rustic or rural scenes. It was just after dawn in the coastal village of Castine that Charlie noticed the boat and its lovely handmade wooden structure. The overhead angle from the wharf's edge gave an interesting perspective [1].

enhance

Charlie initially used Corel Photo-Paint as his retouching program. Adjustment was made for brightness, contrast and intensity, before a small amount of Unsharp Mask was applied to sharpen the shot. However, this appeared too much, so a Gaussian Blur overlay of the original image was placed over the top at around 40–50% transparency. This added a soft glow to the picture and was far more pleasing [2]. At a later stage, the image was reworked using Photoshop, when basic brightening and contrast adjustments were made using Levels. The image was then resized using Genuine Fractals software to approximately 11 x 14 inches, before sharpening and blurring again with the Gaussian effect.

enjoy

'Blue Row Boat' has proved a versatile image. Gallery prints have been sold to private collectors, and it is included in the photographer's 'Quiet Moments' note-card line. It has also been converted to a JPEG with sufficient compression to allow a reasonable download time for web viewing.

> JPEG
> unsharp mask
> gaussian blur
> levels
> genuine fractals
> resized
> gaussian blur

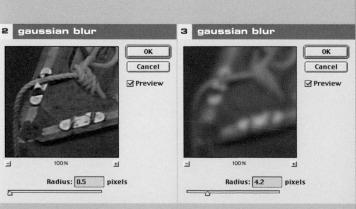

2 gaussian blur — OK / Cancel / ☑ Preview — 100% — Radius: 0.5 pixels

3 gaussian blur — OK / Cancel / ☑ Preview — 100% — Radius: 4.2 pixels

1/ The original image.
2/ 3/ Gaussian Blur is one of the most dramatic and creative filters at our disposal.
4/ The final image.

From portraits to general scenes, Gaussian Blur (Filter > Blur > Gaussian Blur), is a wonderful tool. It enables an image to have varying degrees of blur introduced overall, or to just parts of the image if they are first selected. The effect can range from being virtually undetectable to complete distortion, leaving no sharp detail (3). It can also be used to smooth out the impact of noise. The amount is set in pixels with a radius from 0.1 to 250, but be conservative: most subjects need only a small amount if they are to remain recognisable. Gaussian Blur works, like the less used blur filters, by averaging pixel tones adjacent in hard-edge or shaded areas, but is more controllable. In this case, a special mathematical equation is used (the Gaussian Distribution Equation). You can view the effect in a preview window in Photoshop, which can be magnified to display important parts of the image and moved around within via the Hand tool.

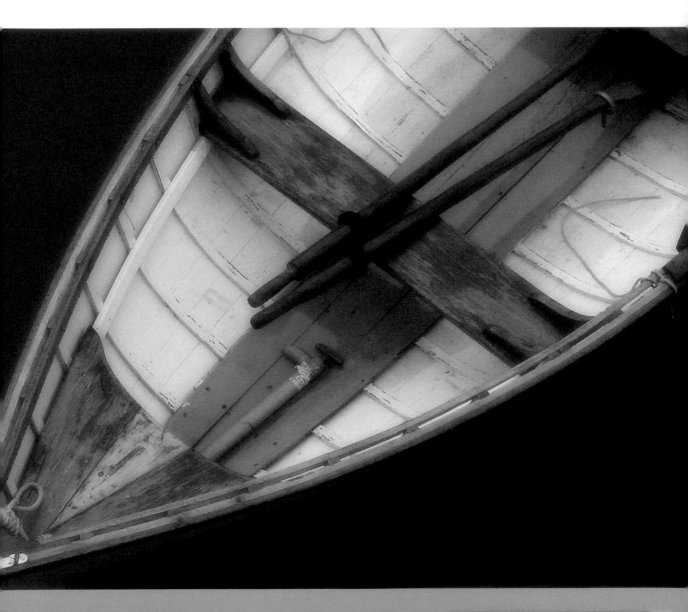

1

dramatic colour

Using digital-imaging tools, the colours in a picture can be transformed to create surreal, dramatic and almost abstract artistic images.

shoot

Walter Spaeth is an award-winning digital artist who shoots with both digital and film SLRs. In this case, he used a film SLR loaded with transparency film and a 100mm f/2 lens, which was used to crop tight into the subject. While the resulting image looks undramatic [1], Walter's vision, combined with digital techniques, created a stunning final image.

enhance

The image was scanned full-frame with a 35mm desktop unit. Opened in Photoshop, it was first copied to make a background layer, then adjusted for its Hue (+20) and Saturation (-44) via Image > Adjustments > Hue/Saturation [2]. The eyelid was targeted for work by selecting it with the Lasso tool [3]. This area was then separated from the rest of the image by

using the Quick Mask feature. If needed, the Paint Brush could be used to add or subtract from the desired area. With this feature, there is little limit to the selection tools or filters that can be used. The Brush tool [4] then enabled the upper and lower parts to be painted via the background and foreground colours selected in the Colour Picker.

> 35mm film capture

> scan

> Photoshop

> hue/saturation

> lasso tool

> quick mask

> brush tool

> lasso tool

> quick mask

> eraser tool

> plug-in

> crop tool

> plug-in

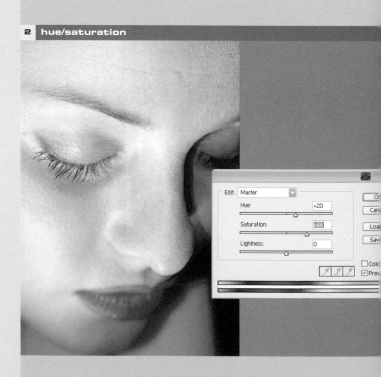

2 hue/saturation

Colours can be adjusted by a number of means. In the Tool Box, the foreground and background colours are easy to select, just as a painter would dab paint from a palette held in one hand with a brush in the other. If you double-click on either the foreground or the background colour, a Colour Picker appears in Photoshop, allowing the current selection to be changed. The small symbols mimicking the larger squares for each, if clicked, return the foreground and background colours to black and white on the toolbox.

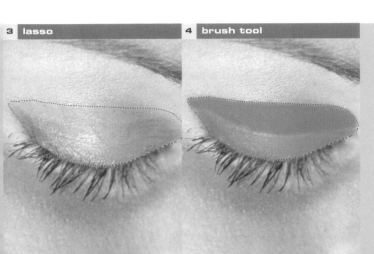

3 lasso

4 brush tool

1/ The original image.

2/ Hue/Saturation adjustments.

3/ Eyelid selection via the Lasso tool.

4/ The Brush tool was used to paint the top and bottom half of the eyelid.

5/ The Eraser tool was set for its opacity, giving desired detail.

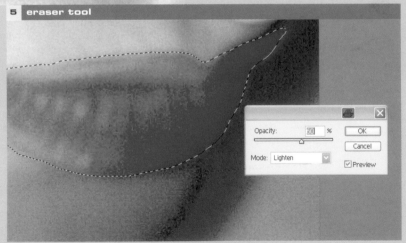

5 eraser tool

Next, Walter moved down the face to the lips, which were selected in the same way as the eyes. However, to lose the detail between the upper and lower lip, the Eraser Tool came into play [5]. This was set for its opacity. 100% erases all pixels, but some detail was left by selecting an opacity value of 60%. If a value apart from maximum is used, the pixels take on the selected foreground colour. The Lighten blending effect was also chosen from the Blend Mode menu.

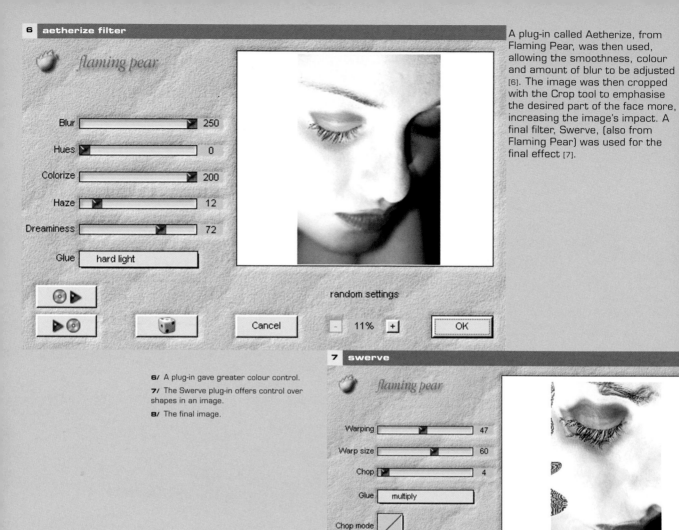

flaming pear

Blur | 250
Hues | 0
Colorize | 200
Haze | 12
Dreaminess | 72
Glue | hard light

random settings

Cancel — 11% + OK

A plug-in called Aetherize, from Flaming Pear, was then used, allowing the smoothness, colour and amount of blur to be adjusted [6]. The image was then cropped with the Crop tool to emphasise the desired part of the face more, increasing the image's impact. A final filter, Swerve, (also from Flaming Pear) was used for the final effect [7].

6/ A plug-in gave greater colour control.

7/ The Swerve plug-in offers control over shapes in an image.

8/ The final image.

7 swerve

flaming pear

Warping | 47
Warp size | 60
Chop | 4
Glue | multiply
Chop mode

random settings

Cancel — 16% + O

enjoy

This image has been in demand for exhibitions around the world. A limited edition of ten 60 x 40cm giclee prints were made. Walter uses an outside source to produce these, but also outputs himself onto A3+ high-gloss paper using a pigment-based ink jet. Thirty of these prints were produced in another limited edition.

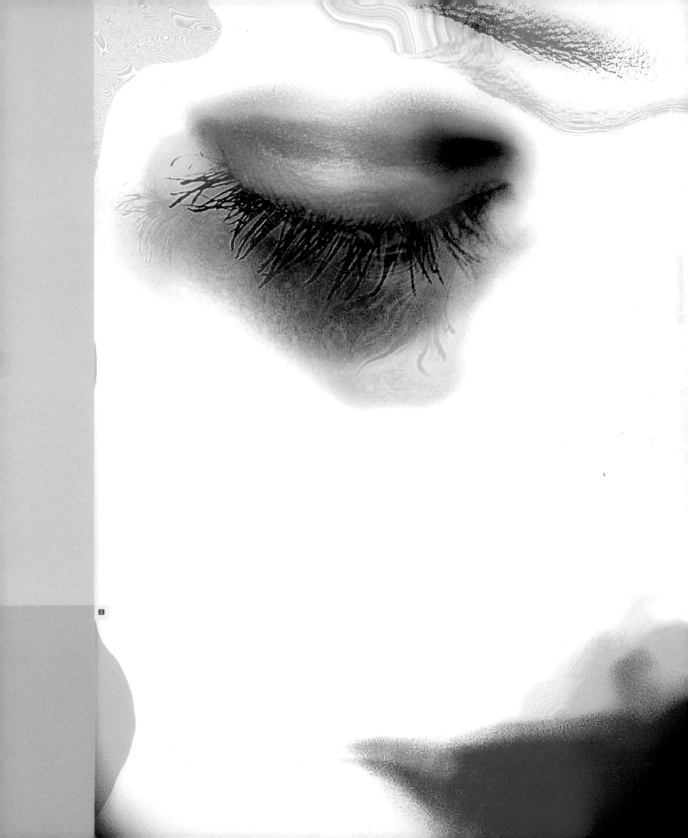

8

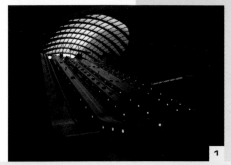

1

Phil Preston was able to see a good shot here, not just because of the scene's dramatic contrasts in lighting, but also because of the simple but effective elements of a large escalator. The shot was taken on a 35mm camera using a 20–35mm lens with 800 ISO colour print film loaded, but even so, reciprocity failure showed up in the result [1].

adding movement

Adding a feeling of movement to a still image can help to grab a viewer's attention. This is not easy to do well, but post-capture control allows interpretation using the numerous software tools at our disposal.

'Develop your image-editing knowledge and skills. The powerful software available today can make a huge contribution to the success, and enjoyment, of your photography.'

> 35mm film capture

> scan

> **TIFF**

> **PhotoImpact**

> levels

> zoom blur

> colour balance

> **JPEG**

> web

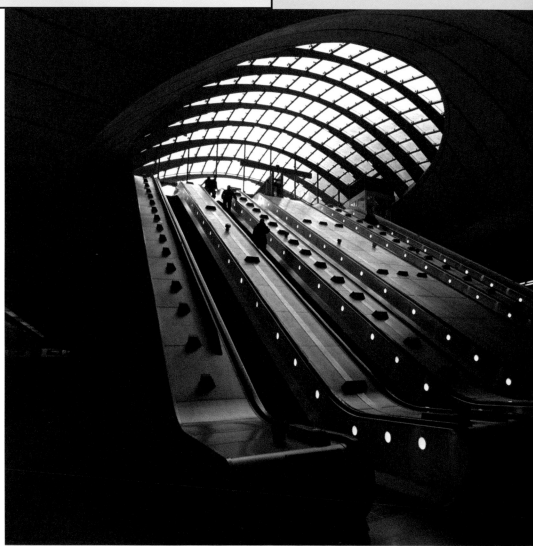

enhance

The image was digitised and saved as a 21MB TIFF file using a 4000dpi film scanner. The resulting image size was 3300 x 2277 pixels. The file was opened in PhotoImpact 8. Levels were used to adjust tonality, bringing out more shadow detail and overcoming the reciprocity effect. Next the Zoom Blur tool was utilised (2). With Dual View

selected, it was possible to see both before and after effects. Then it was time to remove the remaining colour cast that had been recorded originally (3). It is often important to keep the relationship between differing areas of brightness, so the Preserve luminosity dialog box was checked.

Motion Blur

This is a popular Photoshop filter often used to create the feeling of movement. It softens an image by averaging out pixel density around a hard edge. The effect of a moving subject is created by adjusting both the angle, and hence the direction, of the blur, and its strength. It is often better to use both sparingly to keep a feeling of reality.

Radial Blur

This creates a similar effect to the Zoom Blur tool used by Phil Preston. By checking the zoom box, the amount of blur is adjusted, reproducing the effect of a timed exposure when moving a zoom lens. The starting position can be altered by dragging within the schematic box, and effects faded to adjust opacity.

1/ The original image.

2/ Adding blur via the Zoom Blur tool.

3/ Correcting the colour cast.

4/ Photoshop's Radial blur option creates a similar effect to the Zoom Blur used by Phil.

enjoy

This image resides on the photographer's website, prepared using PhotoImpact 8, firstly by reducing image size (using the bicubic method), and lowering

resolution to 72ppi. Then, using the image optimiser, the image was saved as a JPEG file prior to uploading.

When working with layers, it is a good idea to rename them as you go along to help keep things clear in your mind.

working with layers

With today's technology, fewer and fewer images need be thrown away, even if they do not look stunning straight out of camera. What is needed is an imaginative approach to adapt the basic material into something more impressive, and working with layers is a tool that can help you do this.

shoot

David Rowley took his original shot of a café – an everyday scene with some dappled light. It was more of a snap than a considered image at the onset, but with imagination the basic picture was turned into something to be proud of.

1/ Layers.
2/ The Palette Knife.
3/ Hue and saturation adjustment.
4/ Gaussian blur options.
5/ The Dry Brush.
6/ The History palette.
7/ Adding Smart blur.

> crop
> levels
> layer background
> palette knife
> hue/saturation
> gaussian blur
> dry brush
> smart blur
> invert
> poster edges
> soft light blend
> texturise
> adjustment layer
> hue/saturation
> vignette

enhance

Taking the image into Photoshop, David first adjusted the image by cropping to tidy and balance the composition. Levels were adjusted to boost contrast and brightness. Three background layer copies were made simply by dragging the background layer over the Create A New Layer icon. The last two were then switched off by clicking the Eye icon (1) to make them invisible. On the next

1 layers

Normal | Opacity: 100%

Lock:

Background copy 4

Background copy 3

Background copy 2

Background

2 palette knife

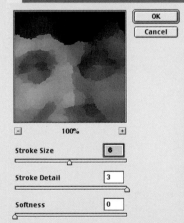

OK
Cancel

100%

Stroke Size 6

Stroke Detail 3

Softness 0

layer, David set to work using the Palette Knife (Filter > Artistic > Palette Knife). This is a wonderful implement for creating a look similar to the way that some artists apply paint. Here, values were set for 6 (stroke size) and 3 (stroke detail) (2). This layer was renamed as 'palette knife'. Saturation was then adjusted to around +70 (Image > Adjustments > Hue/Saturation), and lightness was tweaked by around +5 (3). To enable colours to blend for better effect, David applied a small amount of Gaussian Blur (Filter > Blur >

! Knowing what you have done and in what order can be a significant benefit when working with complex images. The history palette (6) gives clear feedback.

6 history palette

History | Actions

cafe.tif

Open

New Layer

Hue/Saturation

Dry Brush

Smart Blur

4 gaussian blur

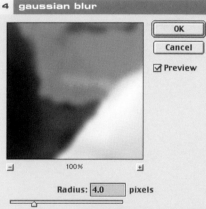

OK

Cancel

☑ Preview

100%

Radius: 4.0 pixels

Gaussian Blur) to soften them. For this, he set a radius of 4.0 (4). On the second new layer, the work was continued using the Dry Brush (Filter > Artistic > Dry Brush). The desired effect was created by adjusting sliders and looking at the preview window (5). This layer was renamed 'dry brush'.

Now the other copy layer was adjusted with the application of Smart blur (Filter > Blur > Smart

Blur). Edge Only was selected from the Mode options (7). A radius of around 15 and a threshold of 52 were used. This layer was called, not surprisingly, 'smart blur'. The white lines against the black background were inverted via Image > Adjustments > Invert. This gave a charcoal-like appearance to the image. The effect can be enhanced; David suggests Filter > Artistic > Poster Edges and playing around

3 hue/saturation

Edit: Master

Hue: 0
Saturation: +70
Lightness: +5

OK
Cancel
Load...
Save...

☐ Colorize
☑ Preview

5 dry brush

OK

Cancel

100%

Brush Size 2
Brush Detail 5
Texture 1

7 smart blur

OK

Cancel

100%

Options

Radius 15

Threshold 52

Quality: Low

Mode: Edge Only

! | *Creating a vignette* For the vignette in this shot, the Rectangular Marquee tool was dragged across the image from just inside the borders and then inversed: Select > Inverse. Using Select > Feather, the radius was set at a value of 15. With the foreground colour set to white on the toolbox, the Paint Bucket was selected from the Gradient tool sub-menu. By clicking in between the selection and borders of the image, the subtle vignette was created. There are plenty of creative options possible simply by experimenting with the size and colour of the vignette.

8/ Layer style.

9/ The final image.

with the options to get the effect you want.

The next stage was to blend the layers together. Soft light was selected as the blend mode (Layer > Layer Style > Blending Options > Soft Light) (8). Near the end of the post-production process, Filter > Texture >

Texturizer was used. There are many different effects that can be added. Final touches included using an adjustment layer to make small changes to hue and saturation once more. Then a vignette was created from a new empty layer.

enjoy

This image appears on the photographer's website.

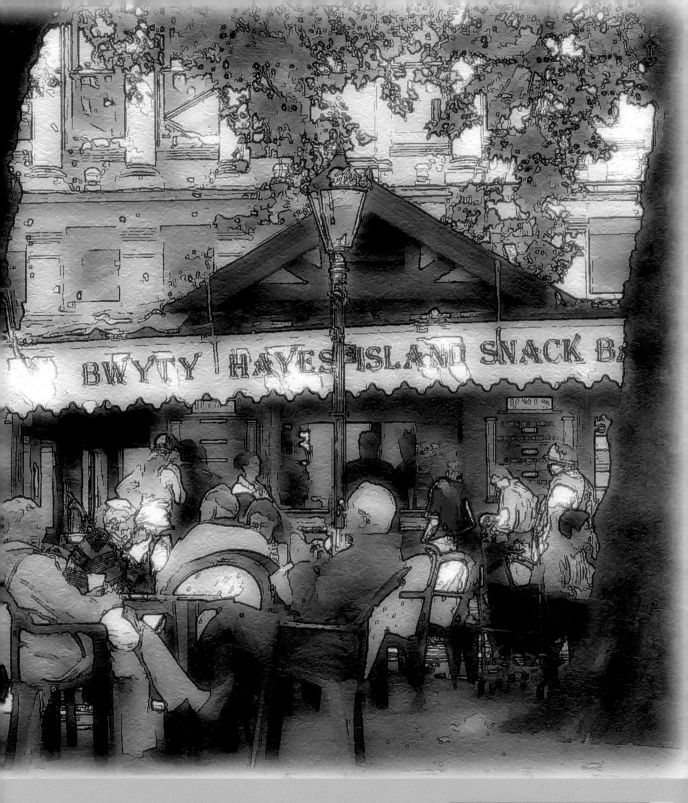

appendix

'Last Ride' by Hans Claesson

glossary

Actions
A series of adjustments and resulting effects made in a sequence. This saves time with repetitive tasks and aids the workflow.

Aliasing
An effect where jagged edges between pixels show when they should be seen as straight or curved. An anti-aliasing filter lessens the effect, as does software using an anti-aliasing process. This reduces contrast between adjacent edge pixels and the resulting jagged look.

Analogue
A continuous signal of information. In the case of film, this gives continuous tone. Digitising images results in a non-linear or stepped series of information.

Bit Depth
The bit depth indicates the number of gradations of tone or colour in an image. The higher the number, the greater they will be.

Black Point
An Eye Dropper tool selects a specific pixel brightness level and changes that to a level of zero (black).

Brightness/Contrast
This is often a basic adjustment made to digital images. Best use can come from working on a specific area using Adjustment Layers or a similar feature.

Canvas
This refers to the area of the image that can be worked upon. You can extend or reduce a canvas to change the shape of an image. This is useful for composite images such as when creating panoramas.

CCD
Charge Coupled Device. This is the light-sensitive component in most high-quality digital cameras and scanners.

Cloning Tool
A popular tool also called the rubber stamp. Used for copying one area of an image onto another.

CMOS
Complimentary Metal Oxide Semi-conductors are increasingly common alternatives to CCD technology inside digital cameras.

CMYK
An abbreviation for Cyan, Magenta, Yellow and Black. These 'subtractive' colours are used to produce colour in paper images including silver halide, ink jet and magazine reproduction.

Colour Picker
A means to select a desired colour.

Colour Space
The name given to the range of colours it is possible to reproduce by a device. No colour space can match the range and subtlety of human vision, but some are more capable (larger) than others.

Colour Temperature
Measured in degrees Kelvin (K), colours are registered differently by camera sensors and film compared to our eyes and brain. This can result in unnatural-looking colour with a tendency to warmth or coolness with different light sources, and sometimes other colour 'casts'. A manual or auto white balance measurement is best used at the time of capture to overcome this. Post-capture adjustment can also be made in many instances.

Feathering
Some selection tools allow parameters to be set to blur edge pixels in an image and smooth the differences between pixels, and this is known as feathering. This term is also used in studio work to describe the edge-lighting effect of a softbox fitted onto a studio flash.

File Format
The data that makes up an image can be created in a number of ways. Each is referred to as a file format. The more common ones are JPEG, TIFF and PSD.

Filter
An on-camera attachment or software process to modify or enhance an image.

Gamut
The range of colour that can be displayed or printed.

Greyscale
The commonly used term for black, white and grey-shade images.

Healing Brush
A variation on the Clone tool that helps keep tone and texture looking natural.

Hue/Saturation
A common means to adjust colours and their intensity.

Interpolation
The term used to describe adding pixels into an image, created by sampling information from pixels nearby. Also called resampling.

JPEG
A very popular file format that uses compression to throw away data to keep the file size down and speed up writing times. JPEG stands for Joint Photographic Experts Group, the combination of companies who originated the idea.

LAB Colour
A flexible means to work with colour and luminance. The latter is separated into its own channel with colours placed in two others. Any channel can be adjusted without affecting the other two.

Layers
This feature is fundamental to working on complex images. Each layer allows specific parts of an image to be adjusted in isolation while other areas are left unchanged. Flattening layers at the end combines them for the final image.

Levels
A straightforward way to adjust image contrast and tonal range.

RAW Data
Basic information gathered by a digital sensor and processed by software. This can be adjusted post-capture in the most flexible ways. It is lossless, but RAW files are considerably smaller than TIFF files.

Resampling
See Interpolation.

RGB
The colours of red, green and blue are used to create images in camera and on a monitor.

TIFF
This stands for Tagged Image File Format. This lossless option offers a stable image file that can be opened by most imaging applications. Creating TIFF files in camera takes the longest time and takes up the most space. However, it is the best quality out-of-camera file format and is preferred for reproduction in book and magazine form.

USM
Unsharp Mask is a means to increase apparent sharpness by adjusting contrast between pixels.

White Point
An Eye Dropper tool is used to select pixels of a desired brightness value and changes them to one of 255 (white). This can help remove a colour cast in addition to brightening an image.

'Church Skyline' by Vikas Shah

contacts

Bruce Aiken

Art colleges in the 1960s encouraged graphic design students to experiment in all fields of visual creativity. This early training left Bruce with a desire and freedom to constantly experiment away from the main field of design, leading to commissions in photography, painting, cartooning and writing. Digital photography and digital manipulation of images has come as a very welcome new field of experimentation.

Some of Bruce's creative work can be seen in postcards and greeting cards published and sold in many countries.

page 86

www.aikengraphics.co.uk

René Asmussen

René's photographic career started in about 1998. He was fascinated by the idea of having an image in your head transferred to paper or canvas. René started to shoot pictures wherever he went. He soon began stripping down the elements in each picture, leaving few things inside the frame to stand out. Photography is, in René's opinion, making things stand out – defining a contrast, both colour-wise and content-wise.

René has won several medals in the Danish Amateur Photography Championship and in the Golden, which is the worlds second biggest amateur photography contest.

page 82

www.asmussenfoto.dk

Jon Bower

As a full-time environmental scientist based in the UK, Jon Bower has been fortunate enough to visit many parts of the globe and create a wide range of landscape and nature photographs. Shooting film originals, he draws upon many digital techniques to create his images.

page 50

www.apexphotos.com

Peter Casolino

Peter studied painting and photography at Southern Connecticut State University and has worked as a photojournalist for the New Haven Register since 1991. He has won numerous awards, including National Press Photographer, Photographer of the Year for the New England Region (1994) and the Editor and Publisher photo of the year 2001. He has had several solo shows and has illustrated 14 educational children's books for Blackbirch Press. His editorial clients include Life, Time, the New York Times, and Washington Post. His agency representation includes The Image Bank and Corbis.

page 110

www.casolino.com

petercasolino@mac.com

Paul Aylett

Paul Aylett has been based in Hong Kong since 1995. He caught the photography bug at the age of nine, when his father, a keen photographer himself, gave Paul his first camera, a German 35mm. It wasn't until his late teens, armed with a Konica FT-1 SLR and a couple of zoom lenses, that Paul took a more serious approach to his hobby. However, turning digital two years ago was a giant leap for him: 'It's great having complete control of the entire process, from image capture to editing and printing – something I never had with film.' Paul now shoots with an Olympus E-10 and edits his images with Photoshop 7 on an iMac. His ambition is to become a professional photographer one day.

page 58

PJAylett@netvigator.com

Theo Berends

Theo Berends describes his work in his own words: 'I photograph on the basis of emotion. The ideas for many of my photographs arise on the spot or during a session. More often than not, a shot entails only the beginning of a process. I linger on what I felt during the shooting, about why, about the backgrounds or the history of the subject. The new information and the new feeling connected with this is added to the photograph at a later moment. For this goal, I make use of modern computer techniques, but I also sometimes scratch the negatives, pile up negatives, or I cut them to create new elements. I keep working on a photograph until my feeling tells me this is perfect now.'

page 22

www.theo-berends-fotografie.nl

Tom Bjornland

Tom Bjornland (born 1952) was a successful photographer in his teens, and won the Norwegian Colour Photography Championship when he was 19. After 20 years as a businessman, he felt the need to do something creative again. He was shown Picture Publisher software and was given the loan of an early digital camera. This mix of new technology and freedom of expression meant that digital photography and post-processing became Tom's creative tools of choice. Tom held his first exhibition in 1997, and was one of the first to use the technology as an art form in Norway.

page 98

www.bjornland.com

Hans Claesson

Hans Claesson was born in 1966 on a tiny island in the North Sea, just off the west coast of Sweden. He sees photography as a medium to make the viewer feel and think – a real challenge both for the artist and the audience. He often uses nature for inspiration, but tries to explore the photographic and human world as much as possible in many different areas. He takes a symbolic rather than a documentary approach to any scene or subject.

page 134

www.go.to/photonart

John Clements

The author, John Clements, works as a professional photographer and contributes widely to magazines about digital imaging, including the British Journal Of Photography, PC Pro and Mac User. He has worked as a consultant for numerous photographic companies, including Nikon UK, where he was their Advisor Of Photography, and Olympus Optical UK. John is the author and co-author of 11 photography books, including A Comprehensive Guide To Digital Landscape Photography, also published by AVA.

pages 34–36, 38, 68

George Dangerfield

Examples of George's work can be found in the archive section of the website listed below.

page 24

www.digitalphotocontest.com

John Deaville

Examples of John's work can be found in the portfolio section of the website listed below.

page 20

www.nxmd.co.uk

Georgia Denby

Georgia has a passion for drawing and painting, and she also enjoys taking photographs, so when digital photography became available, it was the answer to her dreams! She could combine her artistic skills with her photographic interests, and was finally able to create the images she longed for. She says, 'My images get reactions, and that's what it's all about. I have the ability to move people, stir their emotions – be they negative or positive! Most of my pictures are created almost subconsciously. They are elaborate doodles really – I often have no set idea when I start on an image but just allow it to grow and develop as I go along.'

page 28

www.georgiadenby.co.uk

Gry Garness

Gry Garness has been working as a photographer within fashion, editorial, advertising and music photography since 1996 and since 2000 has specialised in digital imaging post-production. She prefers to shoot on film (for its unique qualities), but digital photomontage allows her to create images that are impossible to shoot straight. Gry has a BA from the London College of Printing, but considers herself to be mostly self-taught in the technical aspects of photography. She also teaches Photography and Adobe Photoshop. She is an Adobe Certified Expert (ACE) Photoshop.

Cover image

www.ggarness.dircon.co.uk

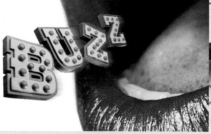

Juergen Kollmorgen

Juergen adopted digital cameras when they became available in the 1990s and used them together with traditional 35mm film cameras. Recently he has been using medium and large-format cameras to explore panoramic photography. Although this involves the use of film, he prefers the digital darkroom to the traditional one. Once the film material is scanned, he processes those photographs in the same way as digitally captured ones. He is willing to do this because he appreciates the very large files that can be obtained from 4 x 5in or 6 x 17cm film.

pages 104–106

www.lightandpaint.com

juergen@lightandpaint.com

Caesar Lima

Caesar Lima specialises in professional fashion, beauty and product photography. The merging of photography and computers is what gives his work an edge. Caesar continually checks out new innovations such as computer-controlled robot lights. 'I am an open door to new ideas, open 24 hours a day,' he says. When thinking about the future, Caesar sees technological advances that will make it possible to exceed current limits and maximise artistic creativity.

pages 30–33

www.caesarphoto.com

John Lund

John Lund has been shooting professionally since 1976. In 1990 he first began to use Photoshop to manipulate images on a computer. John's work has won numerous awards and has been profiled in Professional Photographer, Macworld, PDN, Mac Art & Design, Design Graphics, Photo Metro, Computer Artist, Shutterbug, Commercial Image, Photo Electronic Imaging, Commercial Printer, Digital Imaging and others. John's conceptual stock photography is marketed through Stone, The Stock Market, Workbook Stock, and The Stock Connection, and his studio.

pages 6, 76

www.johnlund.com

Jaap Hart

Jaap Hart considers himself to be a devoted and passionate amateur. Jaap's favourite genres are landscapes and cityscapes, but generally he just likes to make striking pictures. Jaap's home town of Alkmaar and its surroundings, in the northwest part of the Netherlands, are loaded with photo opportunities, such as the cheese market, the woods, dunes, beaches and 17th-century polders with their colourful flower fields, windmills and other typical Dutch features.

pages 10, 52, 114

www.photo.net/photodb/folder?folder_id=25
4108

Thomas Herbrich

Thomas Herbrich exhibits all the skills of a professional, commercial photographer. Digital manipulation allows him to create visually striking results, often combining unexpected components.

pages 118–121

www.herbrich.com

Yann Keesing

Yann's interest in photography started in 1993 when he was given an old camera, a Pentax Asahi Spotmatic. He stopped after about a year, as he was frustrated by having no control over the post-processing phase. A few years later, while studying graphic design at Parson's School in New York, he was introduced to Photoshop and became hooked. He started working as an art director for a publishing company and bought his first digital camera, which he needed for projects he was working on. He found that the digital workflow (from shoot to Photoshop processing) was everything he needed: total control over images! He hasn't looked back since.

pages 88–93

ykeesing@wanadoo.fr

www.pbase.com/ykeesing

Andrew Maidanik

Andrew Maidanik was born in Odessa, Ukraine in 1975. He became fascinated with photography at the age of eight, when his grandfather gave him his trophy 1945 Carl Zeiss 6x9 camera. Shooting portraits, landscapes and spending long hours in a darkroom developing film and making prints has become his lifelong fascination, which transformed into a professional career after his immigration to Canada. Since then, Andrew had experimented with a variety of different cameras and techniques. Over the past few years he has developed extensive expertise in digital photography, the new frontier that captivates him with its virtually endless possibilities.

page 112

www.andrewmaidanik.com

George Mallis

A life-long resident of Long Island, New York, USA, George Mallis draws inspiration from the coastal and landscape beauty of that area. George is a self-taught photographer, and the arrival of digital photography in the mid-1990s opened up an exciting new world of flexibility. George has won numerous awards for his art and has exhibited widely, both in group and solo shows. George serves as the official photographer for the Walt Whitman Birthplace Museum in Huntington, Long Island and has been published in Photographic magazine and New York State Preservationist magazine.

page 14

www.georgemallis.com

gmallis@optonline.net

Royston Matthews

Royston started his professional career in 1985 as a photographic assistant in the studio of a large independent UK-based publishing company. He started freelancing in 1991, primarily for stock travel libraries and commissioned travel photography. He adopted Photoshop for post-production work and is currently involved in the creation of digital originals for various uses and commercial architectural photography of interiors and exteriors in central London company offices.

page 100

www.rjmphotography.com

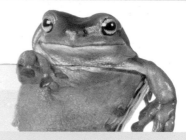

Catherine McIntyre

Catherine is a computer illustrator and artist working in rural Scotland. A propensity for collage – selecting and organising elements, and setting up gestalts from unrelated recycled parts – made Photoshop a godsend. Catherine now does magazine editorial work, book and CD cover illustrations, and greetings cards, and writes Photoshop tutorials.

pages 78–80

http://members.madasafish.com/~cmci/

http://mcintyre.dkx.ru

http://www.intangible.org/Features/
mcintyre/mcihome.html

cmci@madasafish.com

Charlie Morey

Four decades of experience, rich in traditional photography, photojournalism, journalism, creative writing, graphic design and computer graphics, has prepared self-taught digital artist Charlie Morey for his latest endeavour, producing giclée prints based on computer-enhanced digital photographs. Over the years, Morey's images have won international contests, graced the covers and inside pages of magazines, and appeared in exhibitions in US art galleries. His current camera is a Nikon D100, which he uses to enhance his collections of images from Maine, California, Hawaii and Europe.

pages 4, 122

www.digitalphotography.tv.

Natural Moments Photography

Natural Moments Photography is comprised of the husband-and-wife team of Anita Dammer and Darwin Wiggett. Anita has 17 years' experience as staff photographer for the Glenbow Museum in Calgary and is currently doing freelance stock photography. Darwin has been shooting stock since 1990, and has two books published by Whitecap in Vancouver: 'Darwin Wiggett Photographs Canada' and 'Seasons in the Rockies'. Currently, Anita and Darwin are Editors-in-Chief of Canada's Photo Life magazine. In addition to their editing duties they specialise in landscape, nature, animal and humour photography.

pages 62–65, 72–75

www.portfolios.com/NaturalMomentsPhotog
raphy

David Rowley

David took up photography seriously in 1995 and then specialised in black and white. In 1997, a friend introduced him to Photoshop and David was hooked. After a very steep learning curve, he finally began to produce images and in 2001 was invited to join IDIG (Internet Digital Imaging Group). Being a member of a group of like-minded people gave him a tremendous boost. He now concentrates solely on digital imaging, writing tutorials and articles for photography magazines and giving talks on a subject that never ceases to amaze him.

pages 40, 130–133

www.davrodigital.co.uk

Allan Schaap

Allan is a semi-professional photographer who resides in the Netherlands. Although he has had photographic training, he considers himself a photographic artist. Examples of Allan's work can be found on the website listed below.

pages 18, 44

www.photosig.com

Vikas Shah

Vikas Shah is the founder and art director of Ultima Group, a multi-award-winning design agency with clients worldwide. Vikas has more than eight years' experience, and has worked on projects involving travel, editorial, fashion/portraiture and product photography. Vikas writes regularly for a number of magazines and exhibits work at select locations, selling to private and corporate collectors.

page 136

www.ultimagroup.com

John Peristiany

John started photography at an early age, and what then began as a passion soon developed into an obsession. When he discovered the world of digital manipulation, it then became a compulsive pastime. John says, 'Photography is a way of personalising the world in which we live and of giving it a perspective with which we can identify. The same is true of the people that we photograph. Both the technical ability of the photographer and the way in which he communicates with his model are important, but the result will also very much depend on the reaction that she has to him, which is why two portraits or figure studies are never similar when taken by a different person.'

pages 16, 96

peristiany@hotmail.com

Phil Preston

Phil Preston lives in Buckinghamshire, England, and has been an amateur photographer for about 30 years. His main photographic subjects are landscapes, nature and architecture. Phil became interested in digital photography in 1999 after seeing the potential of image-editing software. Following the purchase of a digital SLR camera, he now works exclusively in digital format. His photographs have been published in various UK photography magazines, and he has a website where more of his work can be seen.

pages 54–57, 128

www.digital-fotofusion.co.uk

phil@digital-fotofusion.co.uk

Felipe Rodriguez

Felipe has always loved photography, especially the work of Robert Capa and Henri Cartier-Bresson. He bought his camera, a digital one, in 2000. He has never been inside a darkroom and doesn't think he ever will: he is emphatically a digital photographer, and an obsessive one. Now he has a D-SLR and hates every moment that he can't devote to shooting or editing images.

pages 46–49, 108

www.beatusille.net

Sharon Smith

Sharon has always enjoyed photography but didn't become obsessed with it until 2000, when she purchased her first digital camera. She immediately fell in love with her digital darkroom. Having so much control over the final outcome was exactly what had been missing in her photography. She is now on her fourth digital camera and is focusing her attention on still-life photography. Although photography is currently just a hobby for Sharon, she participates in several online photography sites and has recently started to sell some of her work.

page 70

www.digitalphotocontest.com/archivedisplay. asp

Walter Spaeth

Computers made their appearance in the photography scene in the mid-1990s, and allowed the editing of pictures, something that Walter started doing with great fascination and success. Between 1990 and 2000, Walter won more than 30 awards for his images, and since 1990 he has participated in many solo and group photography exhibitions.

pages 66, 124–127

www.photopage.de

www.artside.de

Wayne Suffield

Wayne works as an English and Media teacher in Ararat, Australia. He took up photography in 1999 to help with his media teaching. His first camera was a Pentax Mz-5n. The internet showed him how to stitch together panoramas, and, after his first success, he was hooked. He uses Panavue Image Assembler for stitching and Corel Photopaint for post-production. He sells panoramas locally and to tourists. His images are on walls (or in attics) in ten countries. He works closely with his wife, Francesca, under the Suffield Panoramas label. His current digital camera is a Minolta 7Hi.

page 94

panos@swiftdsl.com.au

acknowledgements

Any book is the result of a team effort, and we had a good one working on this title. My sincere thanks go in particular to the following people.

First to Brian Morris, for coming to me with the idea, then supporting me while it progressed under less than ideal circumstance – together with his genuinely insightful comments about the choice of images.

I owe a big debt of thanks to Nicola Hodgson, a most professional but relaxed editor, who proved invaluable to me as this book progressed and was very patient. Bruce Aiken's design and truly useful insight into image-making was fundamental to this title and its completion. Thanks also to Sarah Jameson, who painstakingly undertook the picture research for this demanding author.

Finally, my thanks go to those photographers around the globe for being so helpful with our requests, not just for their fine imagery, but also the background information to support it. Without you this would not have been possible.

John Clements